Coloring
For Adults

FOR

DUMMIES®

A Wiley Brand

FOR

DUMMIES®

A Wiley Brand

Coloring For Adults For Dummies®

Published by:
John Wiley & Sons, Inc.
111 River Street
Hoboken, NJ 07030-5774
www.wiley.com

English language translation Copyright © 2015 John Wiley & Sons, Inc.

Copyright © 2015 BBNC uitgevers bv, Amersfoort.

Originally published in Dutch as *Kleuerbook voor Dummies* by BBNC uitgevers bv, in 2015.

All Rights Reserved.

For information about further publication or any reuse, contact John Wiley & Sons, Inc., via email at globalrights@wiley.com.

Published simultaneously in Canada.

For general information on our other products and services, please contact our Customer Care Department within the U.S. at 877-762-2974, outside the U.S. at 317-572-3993, or fax 317-572-4002. For technical support, please visit www.wiley.com/techsupport.

Wiley publishes in a variety of print and electronic formats and by print-on-demand. Some material included with standard print versions of this book may not be included in e-books or in print-on-demand. If this book refers to media such as a CD or DVD that is not included in the version you purchased, you may download this material at http://booksupport.wiley.com. For more information about Wiley products, visit www.wiley.com.

Library of Congress Control Number: 2015945954

ISBN: 978-1-119-17691-6

Manufactured in the United States of America

10 9 8 7 6 5 4 3 2 1

Chapter 1

Color Your World

• •

In This Chapter

▶ Recognizing the benefits

▶ Checking out the most popular materials

▶ Considering different techniques

▶ Touching on color theory

▶ Challenges to boost your creativity

• •

Coloring? Isn't that for kids? Certainly not! Coloring is for all ages.

Whether you're 8 years old or 48, whether you're in school, working in a factory, or have an office job, coloring is a great hobby. It's the ideal way to relax after a hard day and perfect for giving your creativity a boost. For many people, the coloring of a beautiful picture is a kind of meditation. You focus on what you're doing at that very moment and forget everything around you.

This chapter gives you a little intro to the materials you can use to apply color, some different techniques for applying color, and some ideas for taking your coloring to the next level. However, don't feel like you have to read through the rest of this chapter. If you're ready to put color to paper, flip to Chapter 2 and get started!

ABC: Acknowledging the Benefits of Coloring

When you think about coloring even though you're all grown up, you might feel a little silly. After all, you have more important things to do than color in pictures of princesses and superheroes. But that's exactly why you *should* color.

In today's 24/7, on-the-go, stay-connected world, you need to give yourself a break. Your brain needs time to process all the information it's bombarded with, and your body needs time to just rest. Coloring can provide an easy time-out. Grab something to color with and something to color on, and you're all set. You can't find a hobby that gets much simpler.

Check out these other benefits of coloring:

✔ You can do it alone or with a group of friends — or even with your kids.

✔ Coloring feeds the creative side of your mind.

✔ You can spend as much or as little time as you'd like creating your masterpiece.

Mandalas

When coloring is intended as a way of meditation, quite often mandalas are used. *Mandalas* are originally from Tibet and represent a metaphorical map of the cosmos. They usually consist of circular geometric patterns.

For some people, the drawing and coloring of a mandala is a form of meditation. The full concentration on the form brings them rest and creates mental space for new impressions.

✔ There aren't any rules. You can color inside the lines, outside the lines, in one color, in dozens of colors. And you can have multiple masterpieces in the works at once. No one says you have to finish coloring one picture before you start the next one.

✔ You get to be a kid again for a little while — no stress, no responsibilities, no judgment. The final result doesn't have to be perfect, either. If you like it, that's perfection enough.

✔ You may discover something about your adult self as you lay color to paper.

✔ Coloring is a calming activity. People often feel less stressed after they spend some time coloring because it allows them to focus on something other than their day-to-day concerns. Some folks use coloring as a way to unwind before bedtime.

✔ Pursuing creative activities in your free time may lead to improved performance at work.

✔ Coloring pages for adults range from serene to silly, including nature scenes, detailed animal drawings, geometric designs, and cartoon art.

✔ You can hang your finished artwork on the fridge (or frame it and hang it on the wall) for all of your friends and relatives to see.

So take some time to unwind and spend a few minutes coloring. Doing so will add color to your world.

Choosing the Right Medium

When you're new to coloring, the first question you may want to consider is, which material should you use? A pencil? A marker? Crayons? There are many possibilities, and each gives its own result. Let's look at the most popular *media* (the material you use to apply color; singular is *medium*) in coloring.

Colored pencils

Colored pencils are one of the most accessible coloring tools. There are lots of different colored pencils on the market, from simple sets of six to huge boxes with a whole rainbow of colors. Basically, you can work well with any kind of colored pencils, but there are a few things you may wish to consider.

The difference between pencils of good and lesser quality is especially noticeable in their *lightfastness* (a material's resistance to light). The color of good pencils lasts longer and doesn't fade. Also, good pencils don't break as easily as lesser quality pencils.

Another difference is the hardness. Hard pencils last longer, but you need to press harder to achieve a strong color saturation. Soft pencils need less pressure, but they crumble faster. What works best depends on your personal preference and also on the type of paper on which you're working.

When using softer pencils, you can lightly rub the color with a damp cloth to create a nice soft effect. With harder pencils, this effect is much less.

Besides regular colored pencils, you also have watercolor pencils that — when you make them wet — give the special effect of watercolor paint. It is just as if you are painting instead of working with pencil. Watercolor pencils are very versatile. You can use them with other media such as regular crayons, pastels, or watercolor paint. You can also use them in different ways:

- ✔ **Wet on dry:** Use the watercolor pencils as you would use a regular pencil, and afterward touch whatever you have colored with a wet brush. The colors will blend together like watercolor paint.

- ✔ **Dry on wet:** First make the paper wet, and then color it with a watercolor pencil. The lines will run immediately. Make sure you use sufficiently thick paper when employing this technique because wet paper tears easily.

You can let your imagination run wild: Combine dry and wet in the same drawing or coloring page. Or try scraping the color with a knife: Scrape some "crumbs" off the watercolor pencil and sprinkle them on wet paper for a speckled effect.

Most coloring books are printed on ordinary paper, which is less resistant to water than special watercolor paper.

Felt-tip markers

Besides crayons, felt-tip markers are perhaps the best-known coloring material. They are widely available in a variety of colors. Felt-tip markers allow you to create solid areas of color; regardless of how hard you press, the color remains the same. Markers come in different sizes, from very thick to very thin. With a thick marker, you can quickly fill a large area; thin markers are ideal if you want to paint very precise, intricate patterns like some of those in Chapter 2.

Boost a pencil-colored drawing with some marker accents.

If you want even finer details, try colored fine-liners. They are available in many colors and a variety of thicknesses.

If you wish to create a sharp separation and be sure that you don't color outside the lines, mask part of your drawing with removable tape. The masked-off sections of your drawing won't receive the color you're using at that moment. When you're done, you can simply remove the tape and you'll have a sharp color demarcation.

Coloring without coloring

Would you like to do something completely different with your coloring page? Don't color it then, but fill it up with patterns and shapes. By filling in each space with a different kind of pattern, you'll create a very nice effect. Possible patterns and shapes are:

- stars
- circles
- zigzags
- diamonds

- dots
- spider webs
- wavy lines

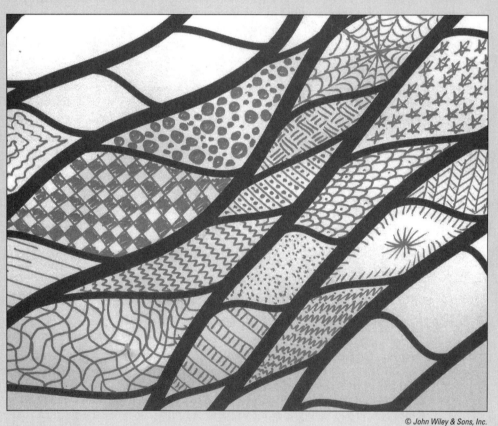

Some markers lay down so much ink that the color can bleed through the paper. If you have another picture or image behind the one you're working on (as in this book), you may want to insert a piece of scrap paper (or several pieces if one sheet isn't thick enough) between the pages to prevent the marker from bleeding onto the next image.

A nice technique to experiment with is painting with markers. It goes like this:

1. **Get a felt-tip marker and a saucer or a small plastic bowl.**
2. **Draw with the marker on the saucer or bowl to get the ink out of the marker.**
3. **Absorb the ink with a moist brush (or moist cotton swab) and use it on your painting or drawing.**

In this way you can easily create a beautiful watercolor effect.

In addition to regular markers with a hard tip, you can use brush pens. These have a flexible brush-like tip, thus creating the effect as if you're working with a paintbrush.

Watercolor paint

Paint comes in many varieties: gouache, oil paint, acrylics, watercolors. . . . Most coloring books are printed on paper that isn't suited for paint. If you have a book with thicker paper, you can experiment carefully with watercolor. Normally you would use a special kind of paper with watercolor paint, and you would need to make it wet beforehand. This is a bit impractical in a coloring book. Fortunately, you can achieve beautiful watercolor effects without passing your book under the tap.

Please note that your paper may wrinkle when you apply wet paint to it. If you use too much water, paper fibers may come loose and make dark spots on your piece of paper.

Watercolor paint is available in many forms: in tubes, in jars, as a pencil, and in the classic paint boxes you probably had as a child. Depending on how much you dilute the paint and what kind of brush you use, you can make large areas of color or paint fine details.

Watercolor paint is a versatile material. You can try your hand at countless methods and techniques. Here are a few examples:

- ✔ With a very wet brush, you'll get transparent color that you might use to add color to air. With a dry brush, you'll get a scratchy effect with lots of texture, which is excellent for animal fur or a stretch of grass.

- ✔ You can make long strokes with your brush for a smooth effect, or try *stippling:* stamping with your brush at right angles to the paper for a spotted effect, perfect for coloring a treetop.

- ✔ You can drop splashes of paint in a contrasting color on your drawing. On paint that is still wet, the splashes will run, while on dry paint, they will remain sharper, sometimes with a darker edge after they've dried.

- ✔ You can mix colors, both on a mixing palette and directly on the paper. If you mix directly on paper, you might want to test first on a scrap of paper to see whether the combination of colors renders the color you're aiming for. Sometimes the mixed pigments create a different color than you might expect.

Because watercolor paint is transparent by nature, it combines well with other media. For example, you could colorize larger areas and backgrounds with watercolor paint, leave the paper to dry thoroughly, and then apply details on top of the paint with crayon or marker.

Pastels

Pastel sticks are a soft kind of crayon consisting of chalk or gypsum combined with pigments. Because they are soft, the material can be rubbed easily, producing a picturesque effect. Precisely because they rub so well, pastels also stain easily, so take care while working with them.

The name *pastel* is actually misleading: You can buy them in the same bright colors as any other drawing media. The term *pastel color,* however, does derive from the use of chalk: In order to get lighter variants of color, chalk was added to the mixture during the manufacturing process. Thus the colors were created that we now call pastels.

Wax pastels and crayons

From pastels based on chalk, wax pastels evolved (also called wax crayons), consisting of a mixture of wax and pigment. Wax crayons are available in every toy store and in all colors of the rainbow.

A popular technique with wax crayons goes as follows: Color your drawing with bright colors, cover all or part of the drawing with opaque black paint, and let it dry. Scratch a pattern in the black paint with a sharp object such as a large nail. The lines in the black paint now expose the rainbow colors of the crayons underneath.

Because crayons are available in so many colors and because you can use one on top of the other, you can make beautiful color gradients. The disadvantage of the cheaper varieties is that they tend to crumble, leaving marks on your paper.

Trying New Coloring Techniques

The most basic coloring technique is scribbling, in which you press color to paper and just move the pencil, crayon, or brush back and forth across the page. When you're ready to take your technique to the next level, you can try one of the many other popular techniques to color in your coloring page. Here are some easy ones to experiment with.

Hatching

One of the most commonly used techniques is *hatching,* which works well with colored pencils and pastels.

Hatching is a way to structure your color areas. You draw lines parallel to each other. If you put the lines closer together, the color will seem darker, and when they are farther apart, the color looks lighter.

You can draw the lines close together for an even-colored area; this is the most natural way of coloring. You can also draw them separately and clearly visible. Vary the number of lines within a given area to let the color go from light to dark.

Cross-hatching means that you first draw lines in one direction and then other lines perpendicular to the first ones. Where the lines intersect, your drawing will be darker. This technique also results in a more even-colored area because you see less of the paper's texture.

You can also use different colors together to get mixed tones. This works especially well with pencil. If you work with markers, be careful that they do not get *tainted* (where the marker you're using to apply color picks up the color that was previously applied to the page) when used one over the other.

Dotting

For a nice result, you can fill your color areas with little dots. This creates an impressionistic effect. Think of the beautiful dotted Aboriginal paintings.

Dotting works with all materials, although using felt-tip markers will result in the brightest, clearly marked dots. See Figure 1-1 for an example of filling in a picture with various sizes and shades of dots.

Texture

Texture in your drawing can be achieved in various ways.

When working with paint, you can imitate all sorts of different textures, for example by stamping or working with a dry brush. You can also use an object other than a brush to apply the paint to the paper. For example, you can stamp with a sponge or use a piece of cloth to smear the paint. Thus you can create all kinds of rough textures in your drawing.

When working with pencils or pastel crayons, you can create very nice textures. The easiest way is called *rubbing,* which involves putting something with a well-defined structure underneath your paper, and then rubbing the paper with your pencil (see Figure 1-2). The object with structure could be anything: a reed mat or a wooden board with a clear grain, a lace doily — whatever tickles your fancy. The higher parts of the structure will result in darker colors.

If you wish to slightly blur the texture of your colored pencils, gently rub your work with an eraser. This works best on softer pencils.

Depth

If you want to add depth to your drawing, try to make the edges of the color areas darker than the center. Make sure the transition from light to dark is very gradual. This gives a nice sense of depth to your drawing.

A different way of creating depth is by giving the background a lighter color than the foreground. Try coloring the background overall with a thin layer of paint, and then work in more detail when filling in the foreground, using bold colors.

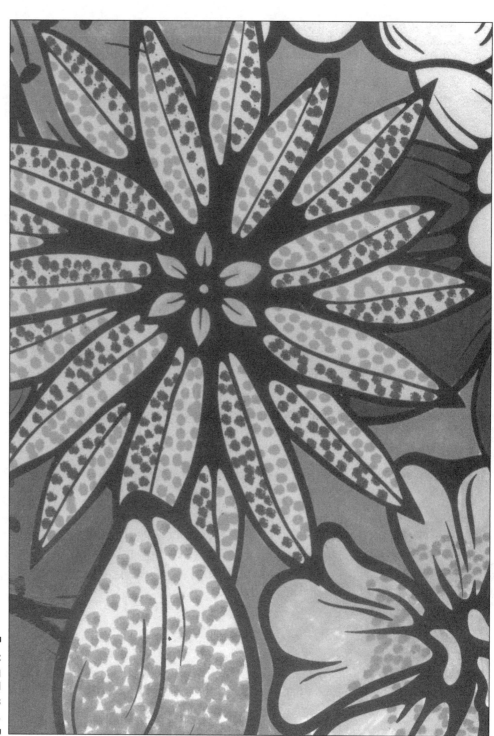

Figure 1-1:
Dotting
applied
in various
ways.

Professional coloring

For most people, coloring is a hobby, a way to be away from everyday life for a few minutes. But some people practice the art of coloring as their profession. In the world of comic books (and these days an increasing number of web comics), being a colorist is a serious profession. Although many cartoonists color their own artwork, there are also plenty of comic strips that are drawn by one person and then colored by someone else. Especially in American comics, the colorist is of major importance. The color palette used can be a determining factor for the tone of a comic strip, and a good colorist is therefore very important.

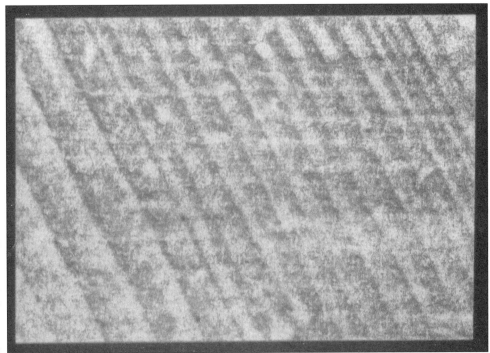

Figure 1-2: Pencil rubbed over an object of wood to add texture.

© *John Wiley & Sons, Inc.*

Tuning Up Your Color Sense

Choosing the colors for your work of art can be the most intimidating part of the process. After all, you want to get everything just right, but undoing a color that doesn't look right or isn't in the right place is nearly impossible. So how do you move past your fear of colors? Keep reading for some hints on choosing colors that work well together and selecting hues that reflect what you're feeling.

Color theory

You can use any colors you like when you're coloring. Are you crazy about neon colors? Is purple with orange your favorite color combination? Go wild! After all, it's your coloring book!

For those with a less pronounced preference for specific colors, here are some tips on the use of color. A useful tool for a discussion about colors is a color wheel. This wheel is composed of the three primary colors: red, yellow, and blue. Where the primary colors overlap, you'll find the secondary colors orange, green, and purple. In between are various other shades. (Check out www.dummies.com/extras/coloringforadults to see an example of a color wheel.)

The colors on the color wheel that are close together are in harmony; they fit well together. Colors on the wheel that are opposite each other display a maximum contrast. So if you want to achieve an amazing effect, try combining blue and orange for instance. If you prefer a more harmonious result, a combination of blue and purple would be a better idea.

How a color comes across partly depends on what colors surround it. A red area within a yellow surface will seem much darker than the same red area on a blue background.

If you keep these things in mind, you can play with color. For instance, try using contrasting colors to outline the bigger shapes, and then fill these in with harmonious colors.

Color and emotion

Different colors evoke different emotions. Apart from personal preferences — what is your favorite color? — colors have a more universal psychological meaning. Well-known of course is that red stands for danger, passion, and fire, and white for purity and peace. But other colors also have a psychological effect.

- **Red:** Danger, passion, love, fire
- **Blue:** Power, dignity, clarity
- **Yellow:** Energy, lightness, joy
- **Green:** Nature, peace, fertility
- **Violet:** Wisdom, spirituality, strength, healing

Associated with this topic is the so-called color temperature. Colors can be divided into warm and cool colors. Warm colors are red, orange, yellow, and everything in between. Cool colors are blue, purple, green, and whatever shades are between them. In general, warm colors are seen as active, while cool colors are perceived as soothing. If you would like to give your coloring page an air of relaxation, choose many shades of blue and violet.

Ten Challenges to Sharpen Your Creativity

Check out these ten challenging tips to make you feel confident about getting to work on the coloring pages in this book!

✔ **Use only a ballpoint pen:** Pretend you are sitting in a boring meeting and color your page with only an ordinary ballpoint pen. Experiment with the pen pressure to make lighter and darker areas of color. Use different types of hatching.

✔ **Then try a colored pencil:** Choose one color and use it for the entire coloring page. Vary with light and dark, shading, and different textures. Can you work with just one color to create a varied whole?

✔ **Go in circles instead of lines:** You're probably naturally inclined to use lines when coloring, but try using small circles instead (see Figure 1-3). By using a different way of coloring, you'll need to concentrate more and therefore will be even more detached from your surroundings for a while.

✔ **Mix 'n' match:** Use as many media and techniques as possible in one coloring page: pencils, paint, pastels — go wild!

✔ **Create a rainbow:** Start coloring on the left side of your page in shades of red and then turn to orange, yellow, green, blue, indigo, and violet. Try making the transitions look as natural as possible.

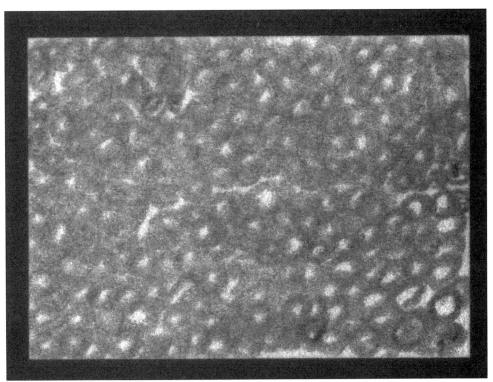

Figure 1-3:
Small circles instead of lines.

- ✔ **Experiment with a white wax crayon:** Take a white wax crayon and make sure it has a good tip. Draw some simple shapes within larger areas of your coloring page. Now color the page using felt-tip pens and/or watercolor paint and see what happens.

- ✔ **Change the tone with tertiary colors:** Forget red, yellow, and blue, and try coloring a page using (mainly) browns, olive green, gray-purple, ochre, and so on. Take a plunge into the duller colors and discover that they too can be magnificent.

- ✔ **Viva veggies!** If you want to get closer to nature while coloring your pages, use natural pigments. Take a handful of vegetable material, grind it finely in a mortar, and then push the resulting mash through a piece of cheesecloth or coffee filter. The colored liquid can be used as watercolor paint. Use the following natural plant material to create natural color:

 • **Red cabbage:** Purple-blue

 • **Spinach:** Light green

 • **Beetroot:** Red

 • **Nasturtium:** Orange

 Experiment with different kinds of flowers and plants and check out the resulting colors.

 These natural pigments are less colorfast than real paint and ink, so don't be disappointed when, over the course of time, they fade.

- ✔ **Grate your pencils:** Use a grater or knife to remove some powdery material from your pencils, and then wipe it over your drawing with a piece of cloth. Experiment with material from different colored pencils, using all at the same time.

- ✔ **Try a blind date:** Take all of your pencils or markers, close your eyes, mix them up, and then blindly pull out five or six. No cheating! Use this selection for your coloring page and try to create something truly beautiful.

Chapter 2
Coloring Canvases

●　●

*I*n the following pages, you'll find more than 100 images to color. Included are detailed drawings, geometric designs, and nature images. Color them however you'd like.

Note: The left-hand pages in this chapter are blank so whatever media you use to color a picture doesn't ruin an image on the reverse side. If the ink you're using bleeds through to the next image, place a piece of scrap paper between the pages. (You can test for whether this is going to be a problem by doing a bit of free-form coloring on this page or on one of the pages earlier in the book.)

You can find additional coloring pages online at `www.dummies.com/extras/` `coloringforadults`. The five pages there range from simple designs to more complex ones. Enjoy!

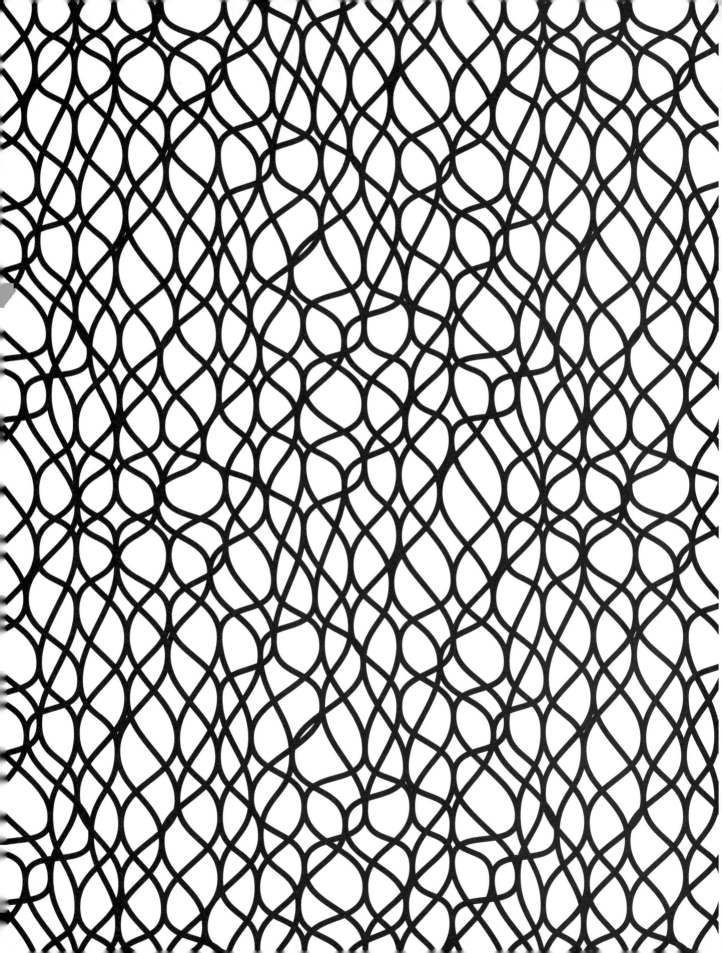

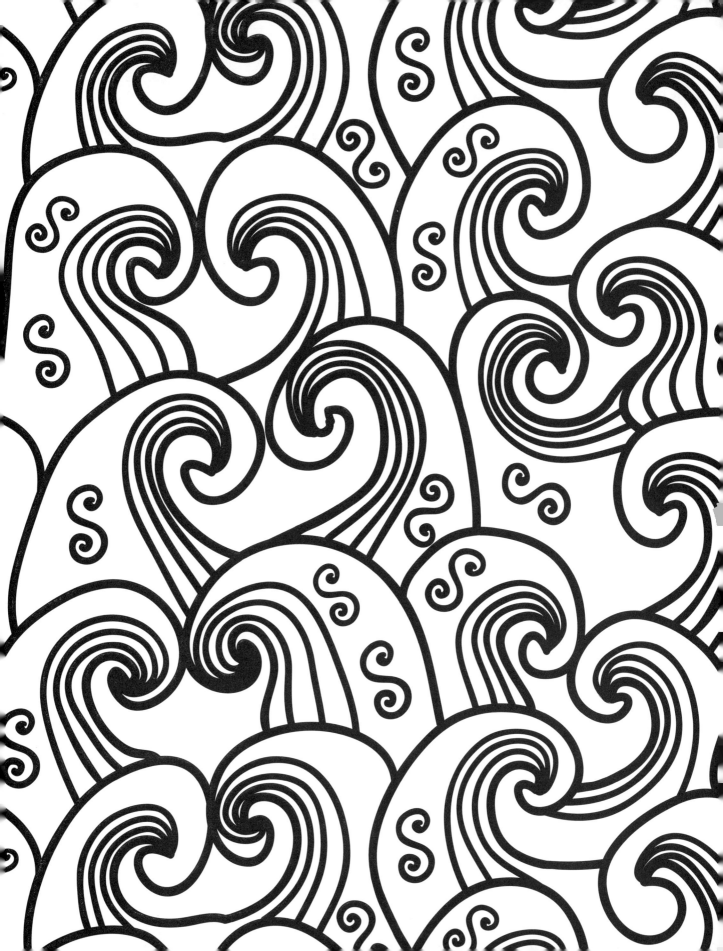

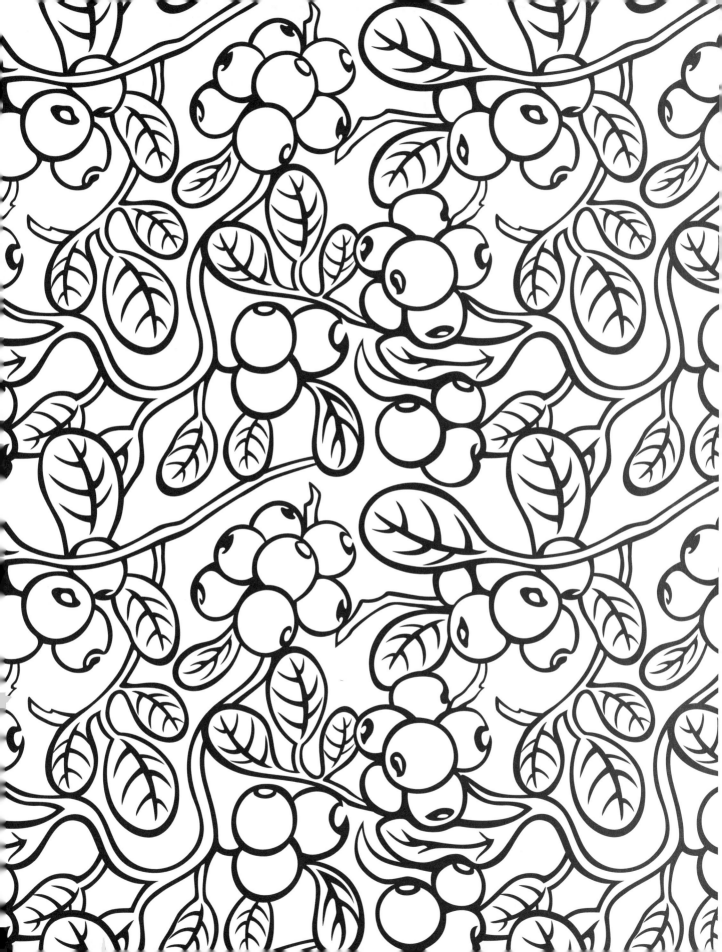

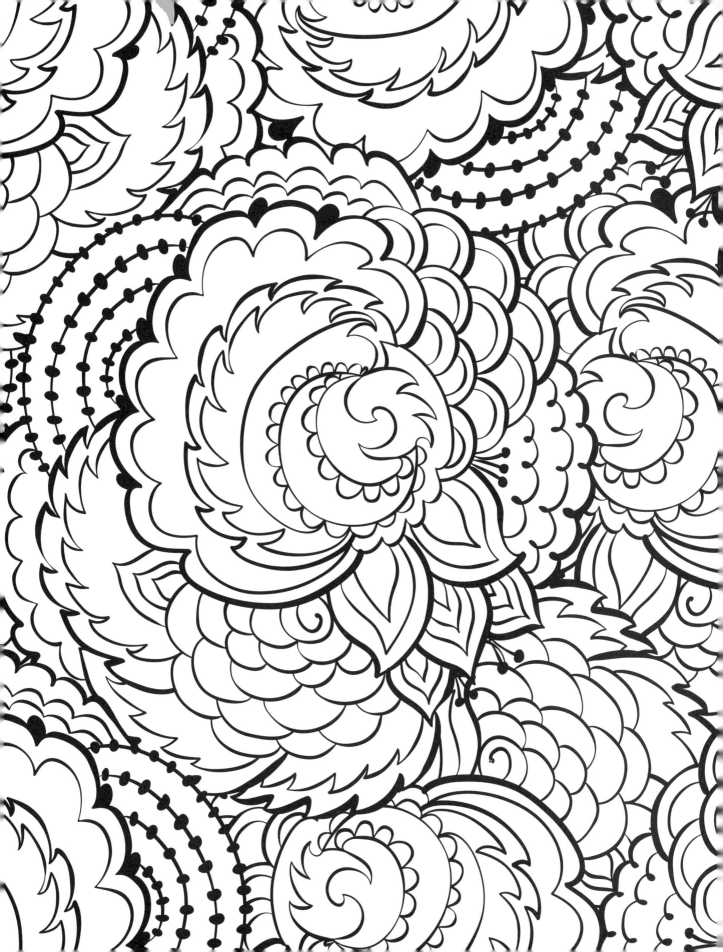

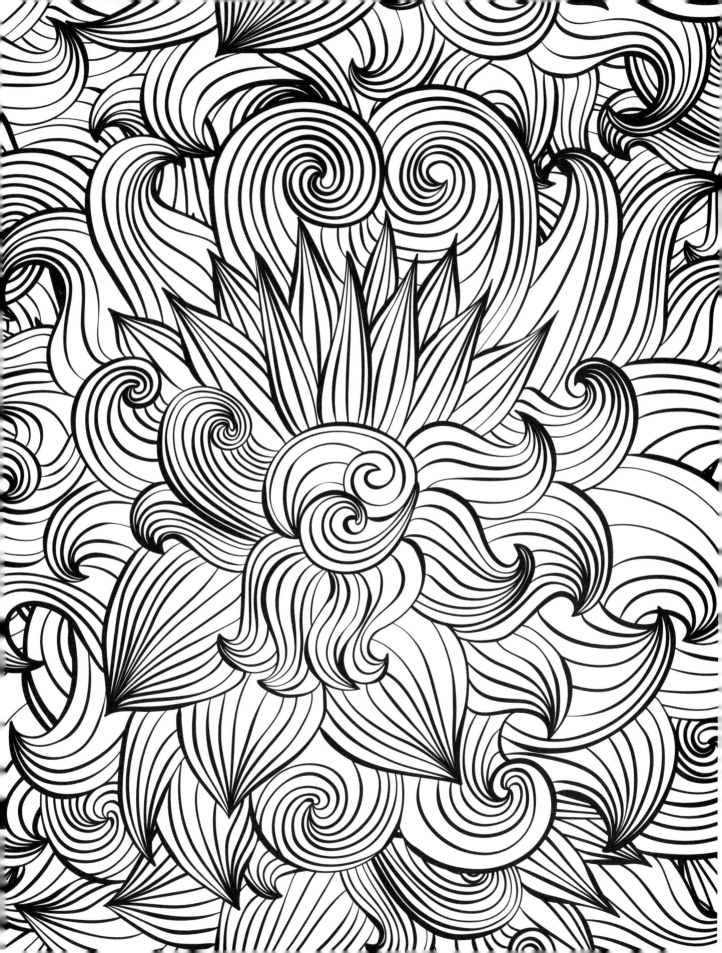

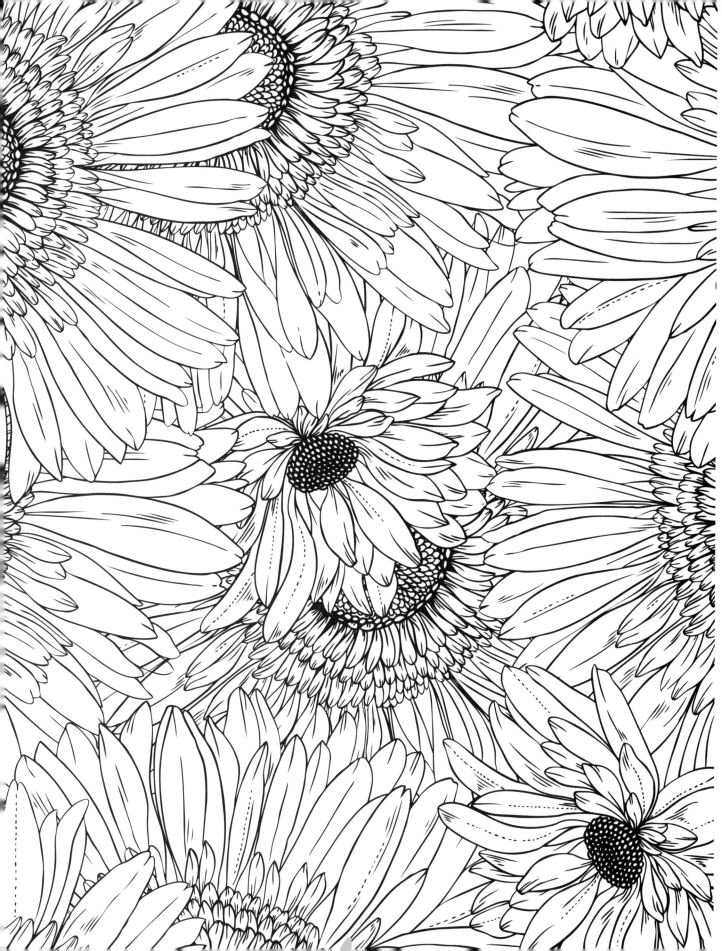

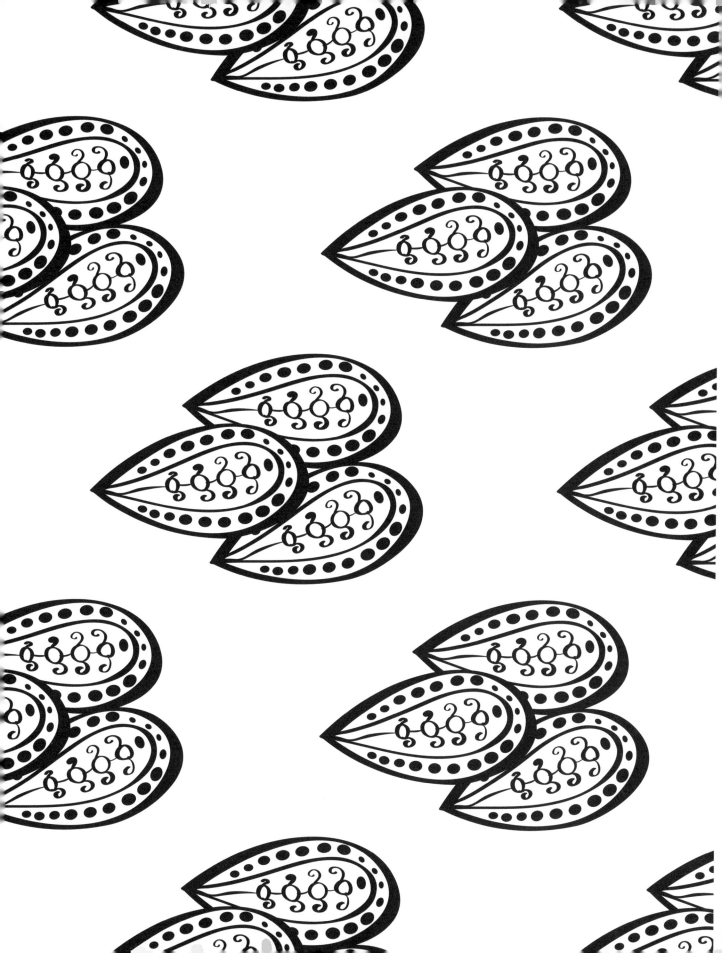

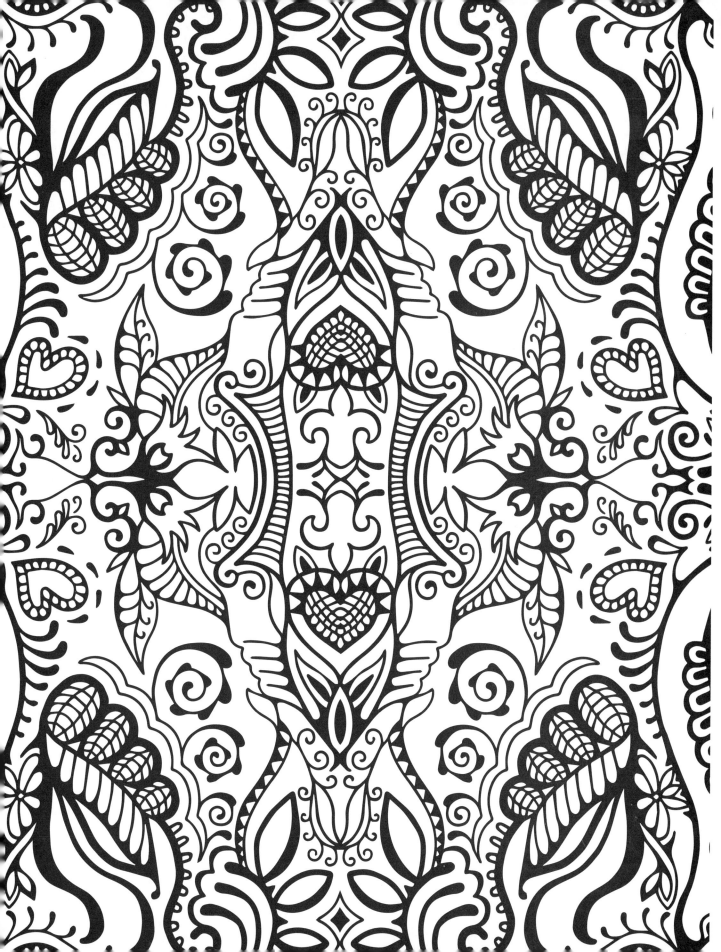

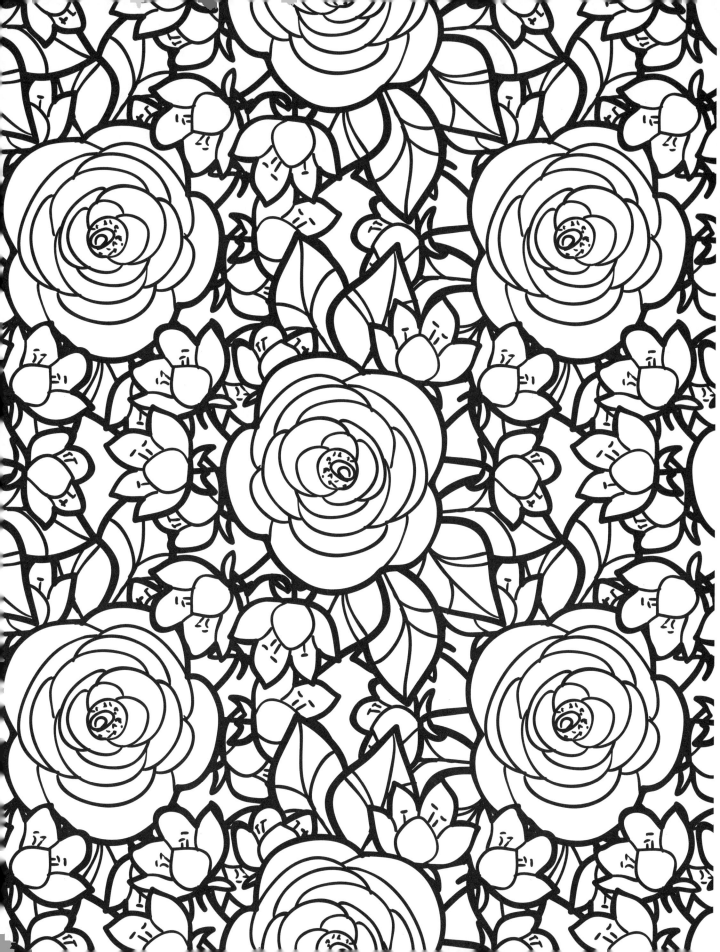

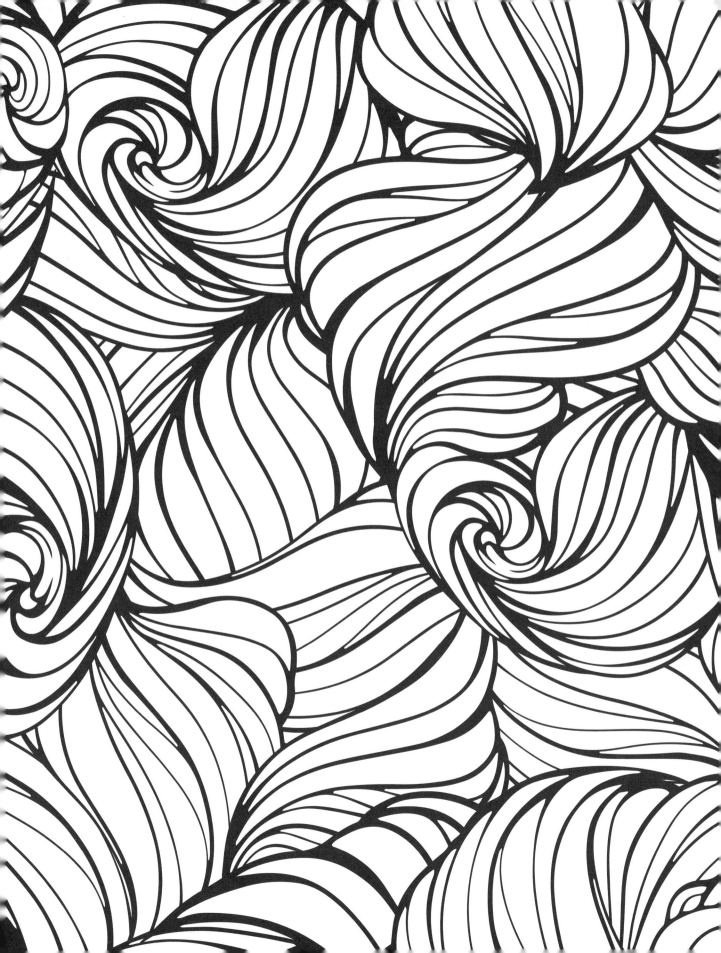

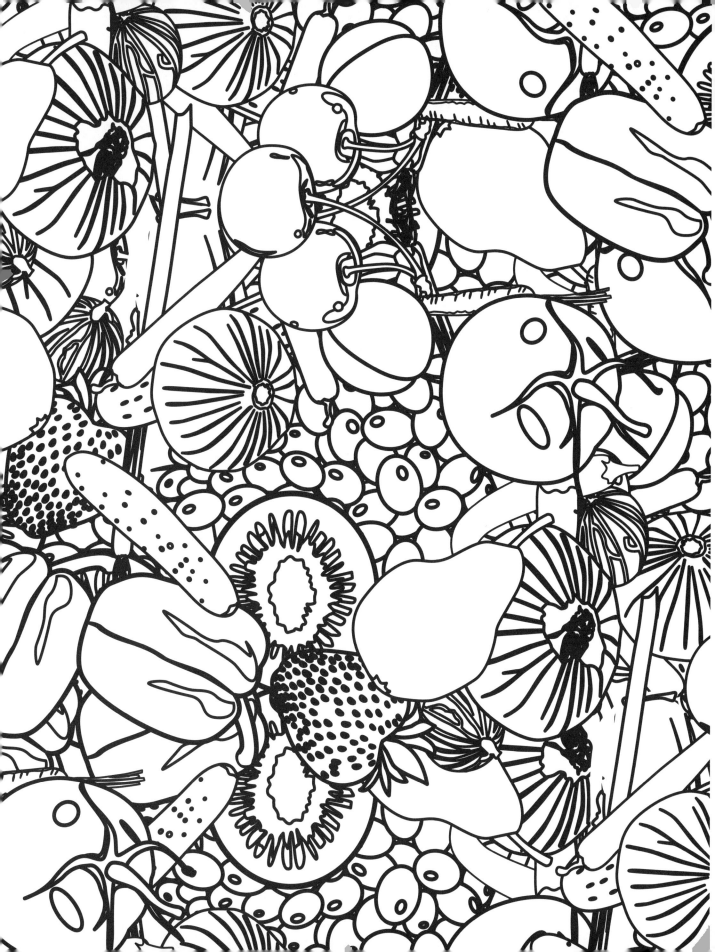

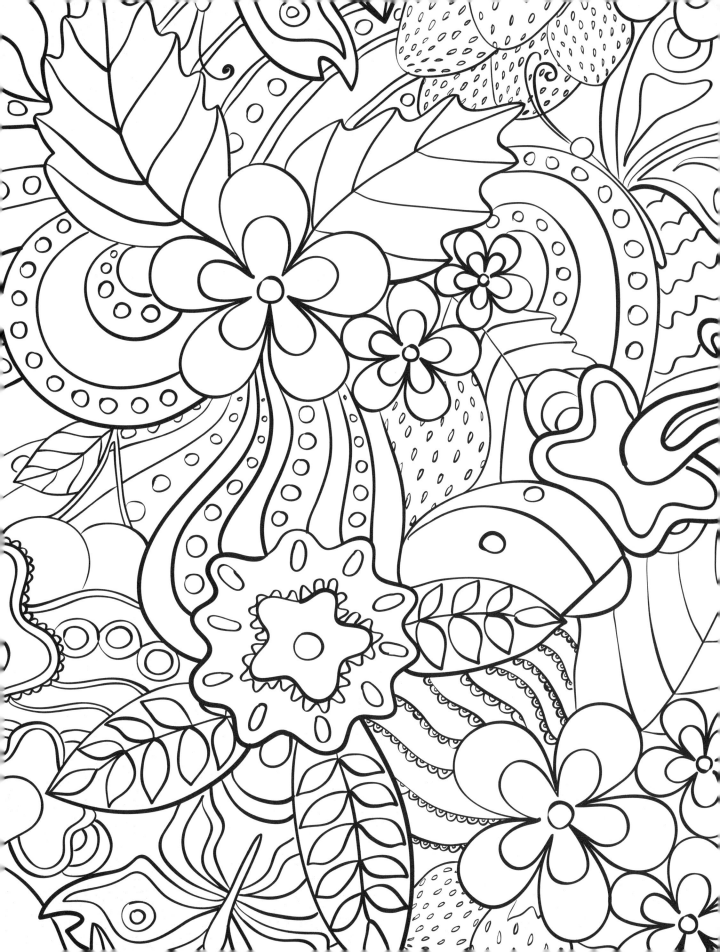

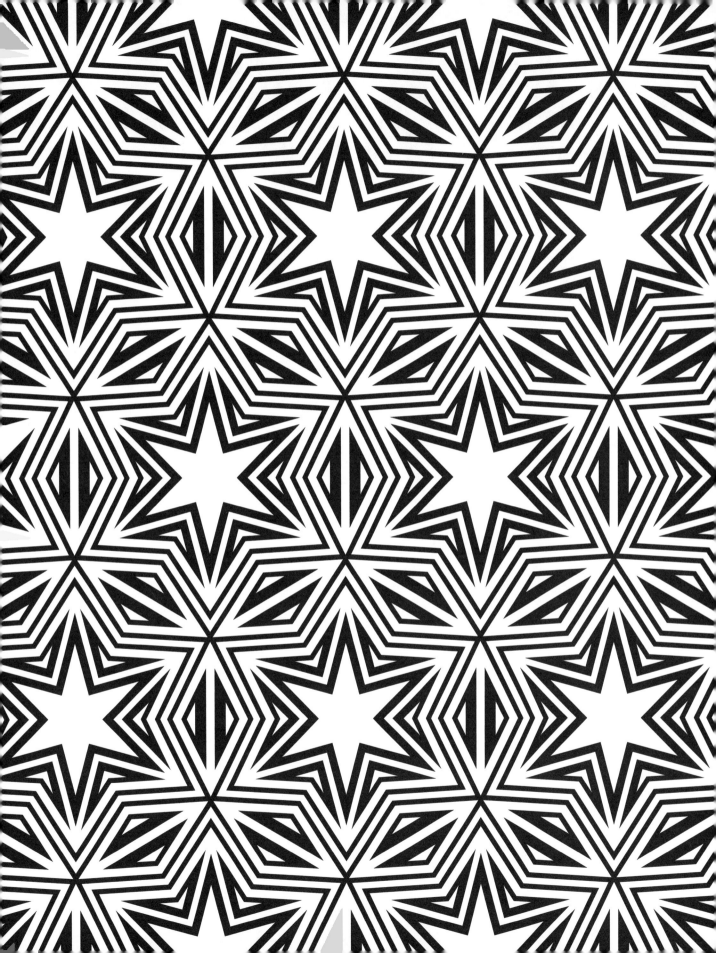

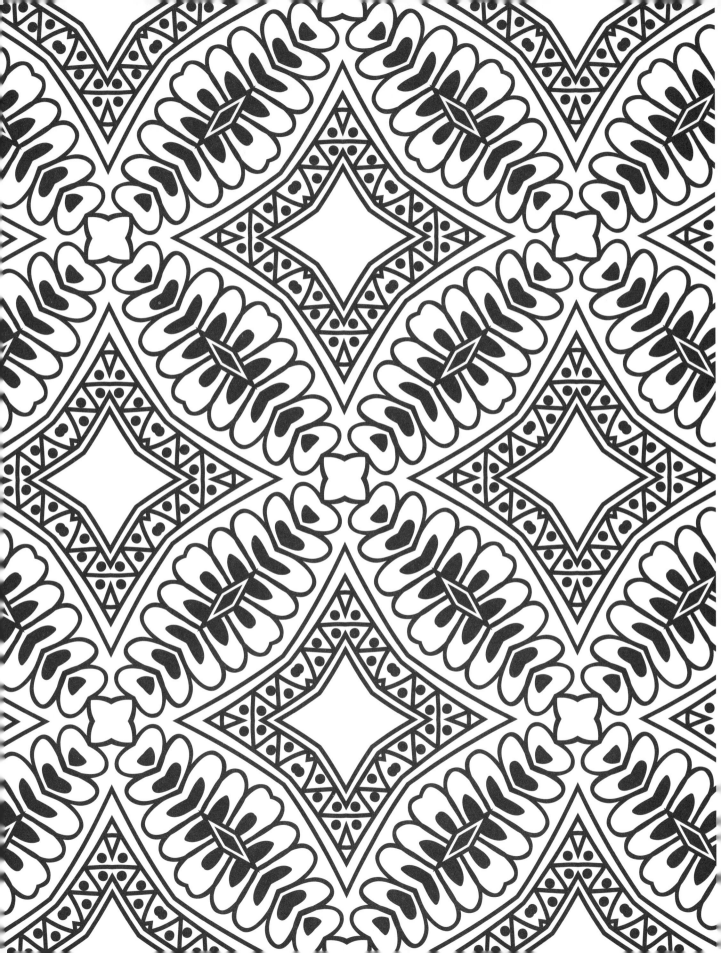

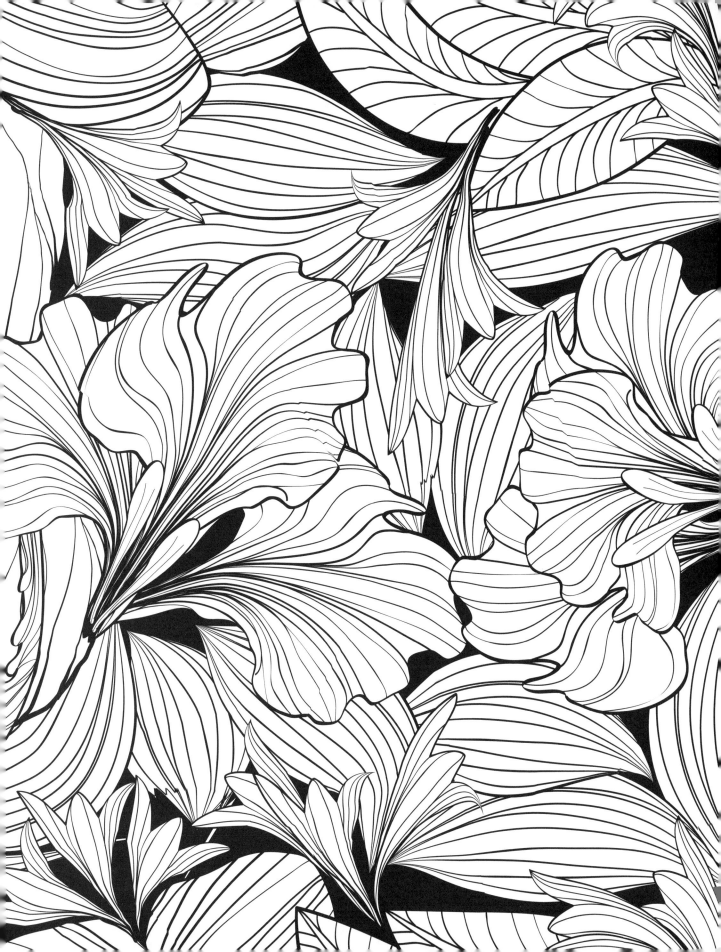

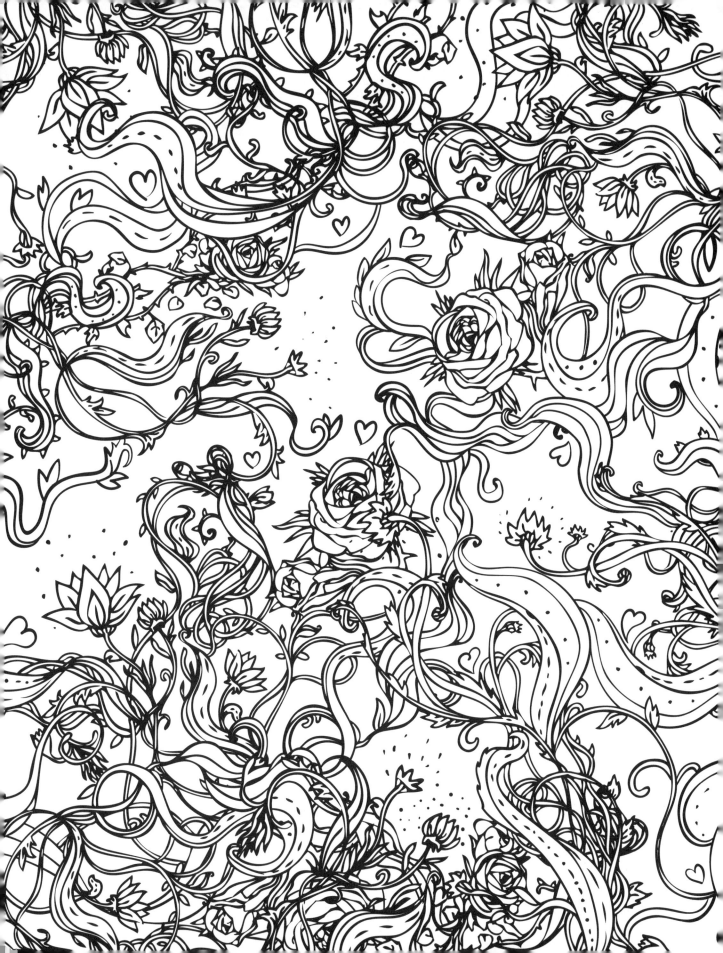

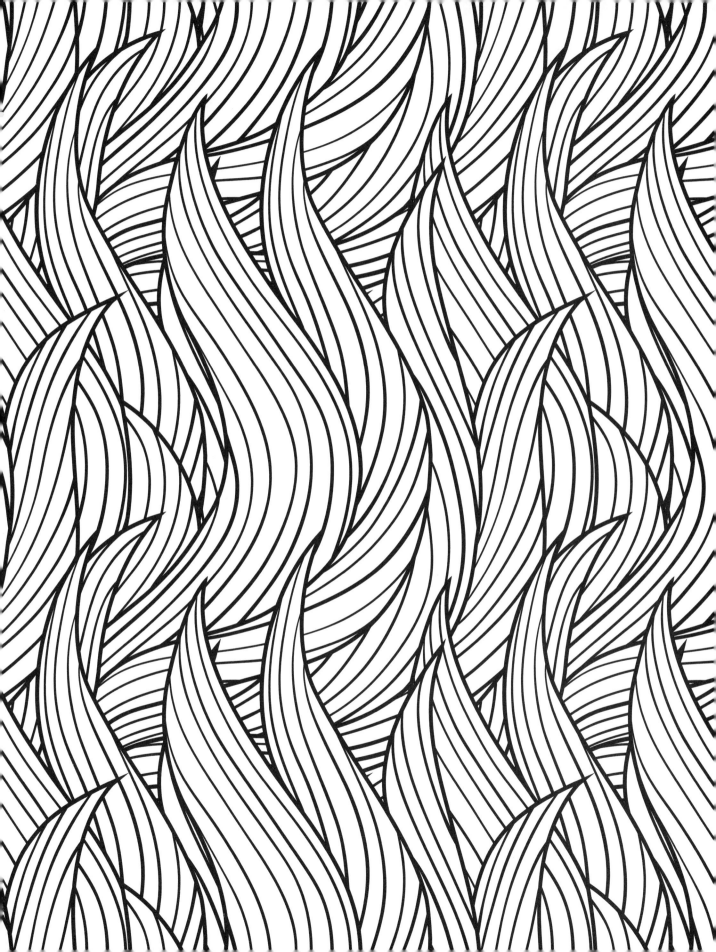

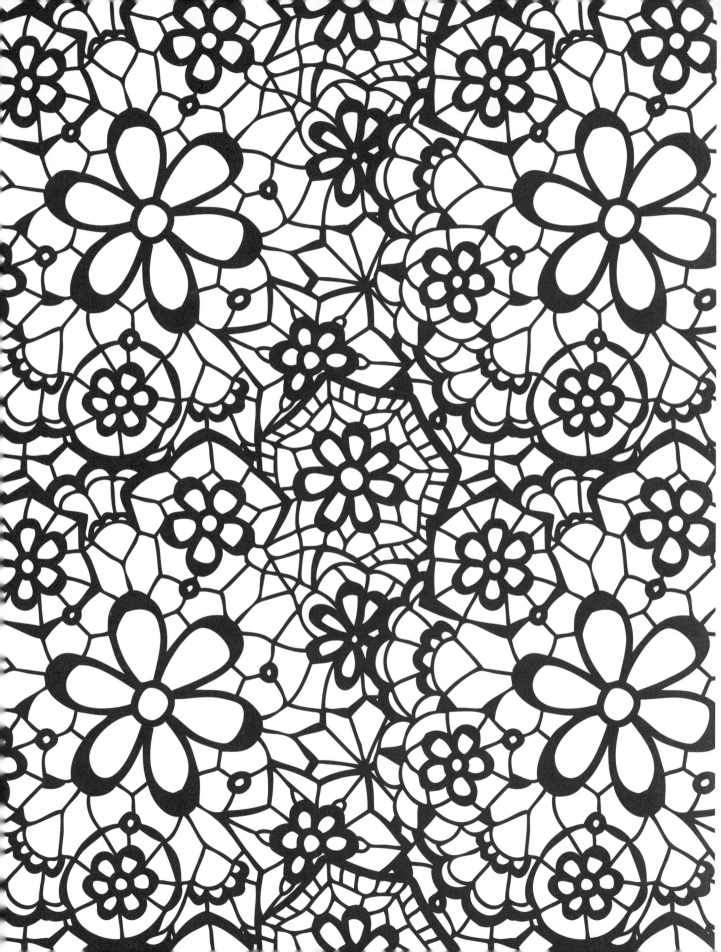

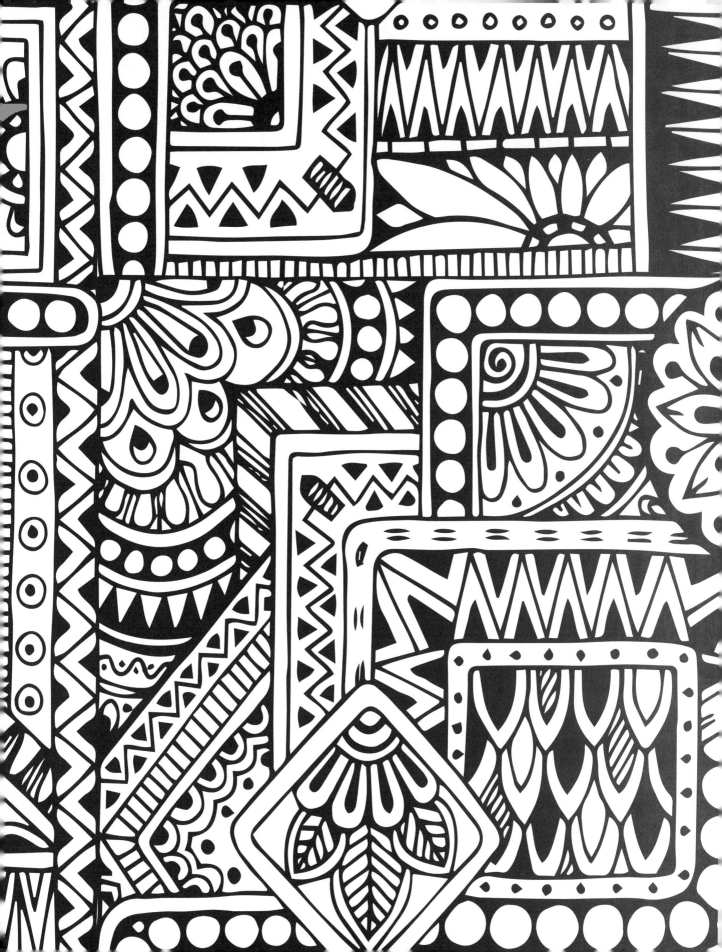

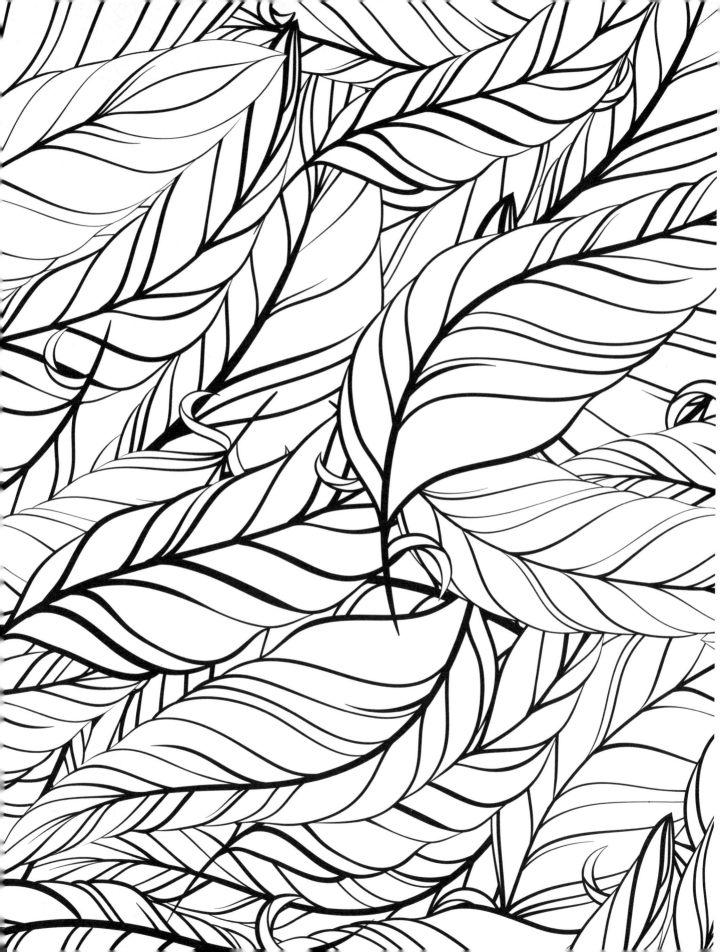

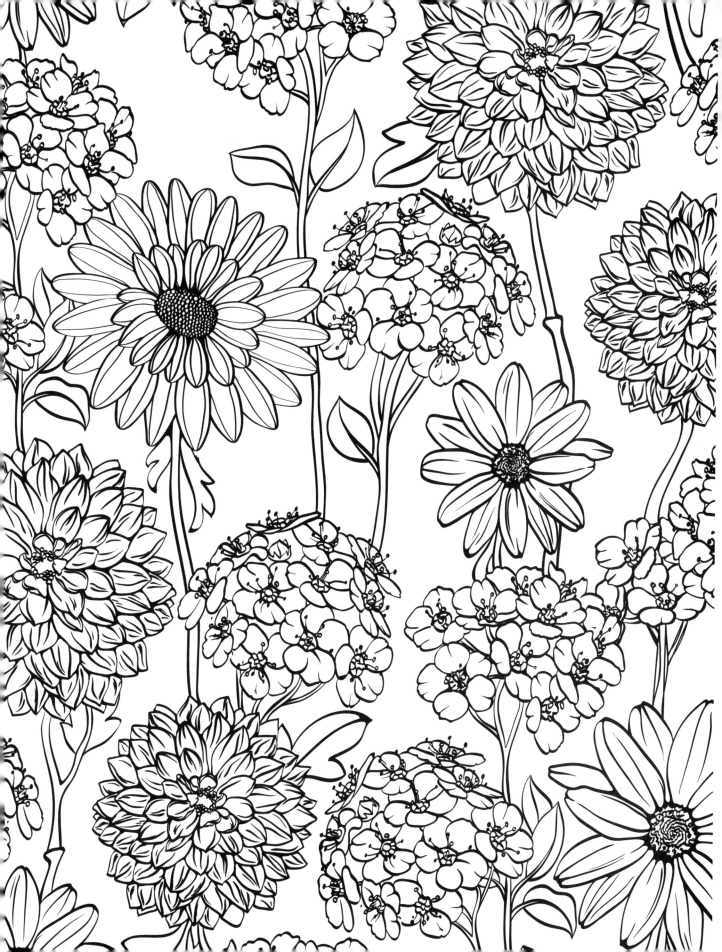

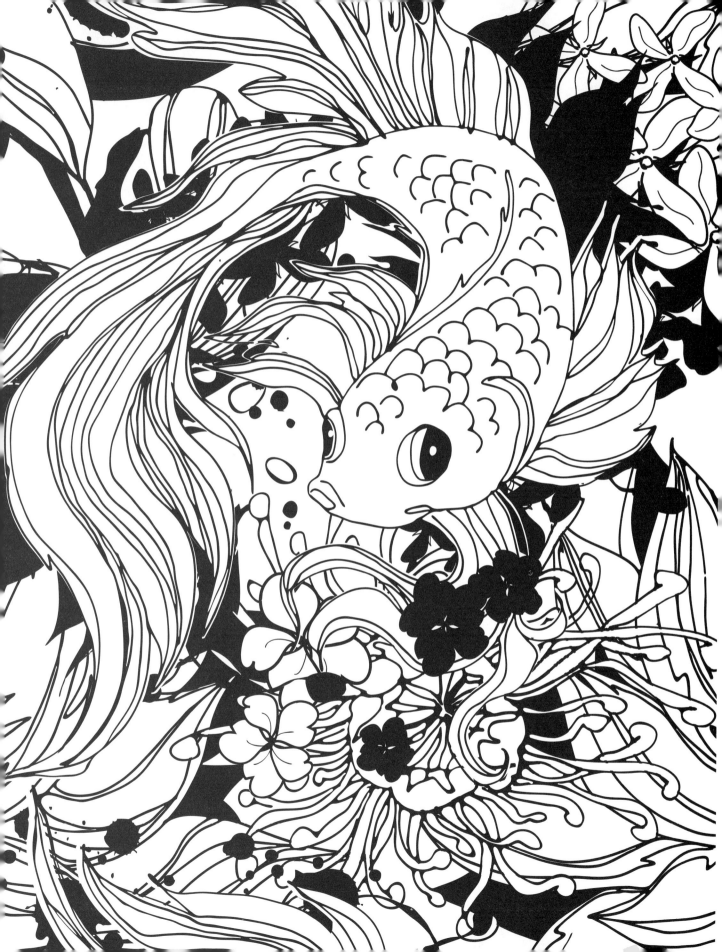

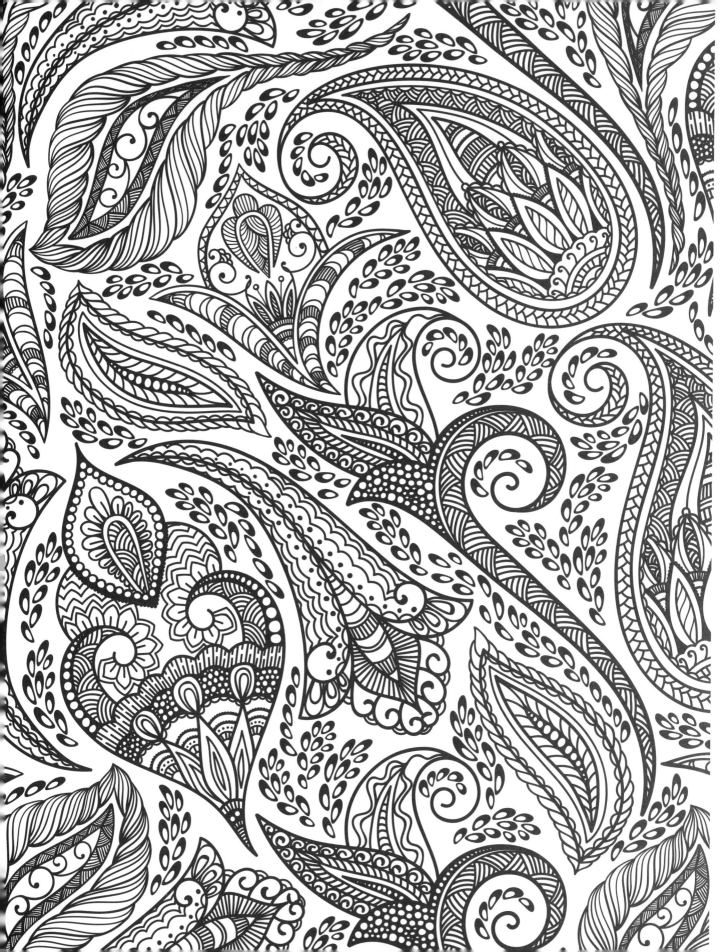

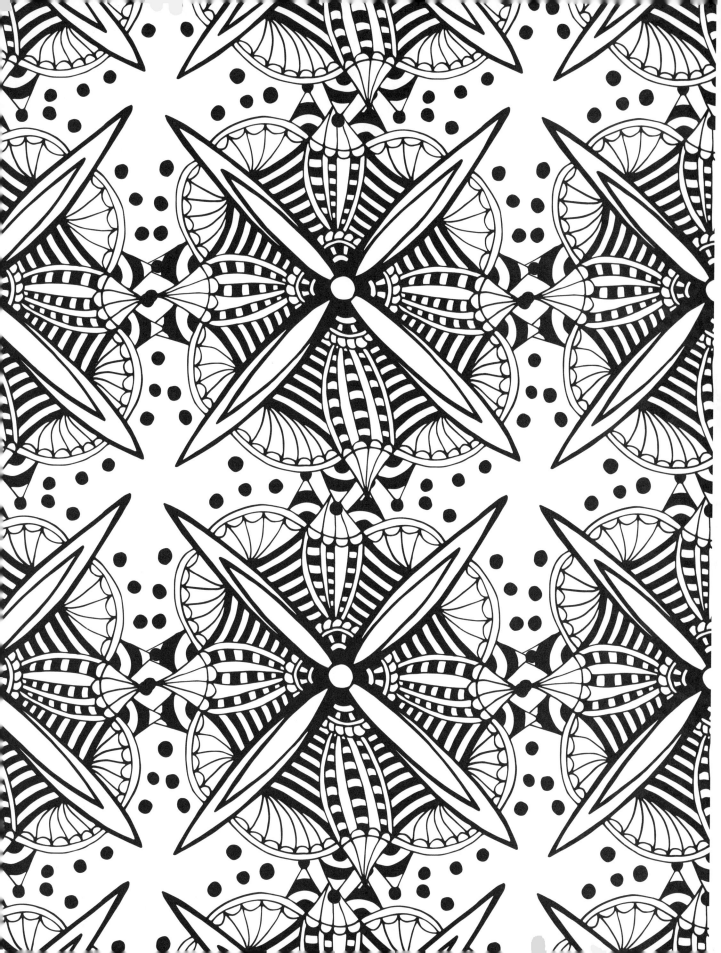

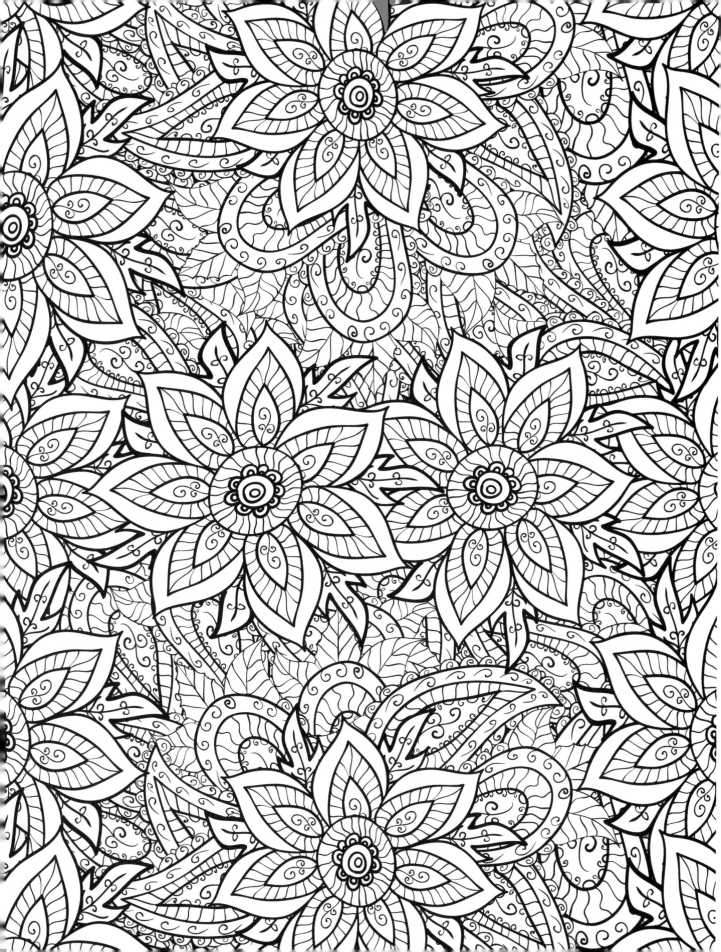

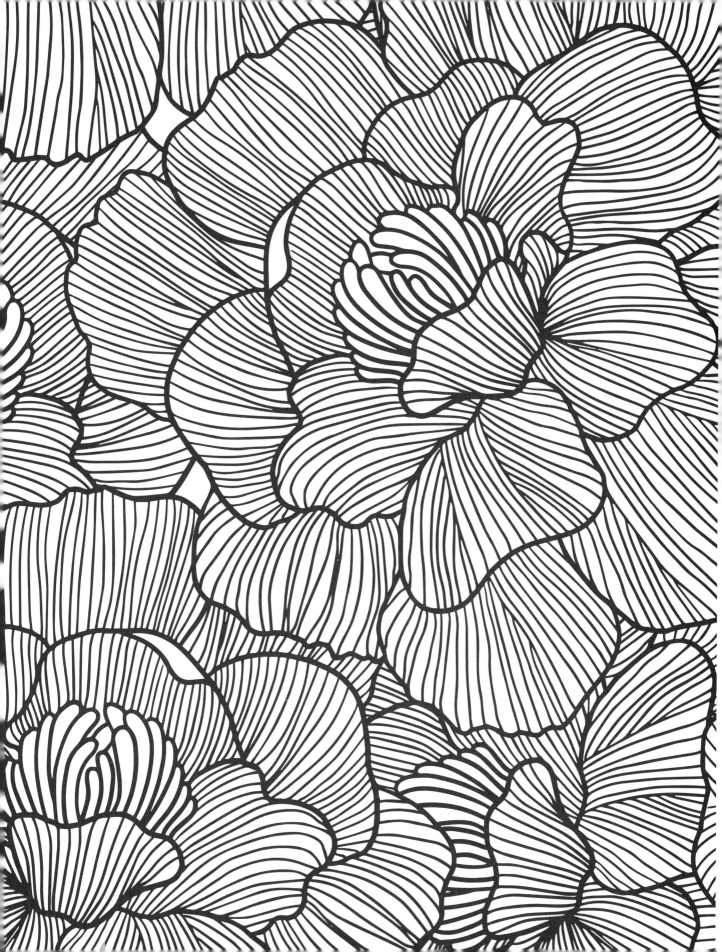

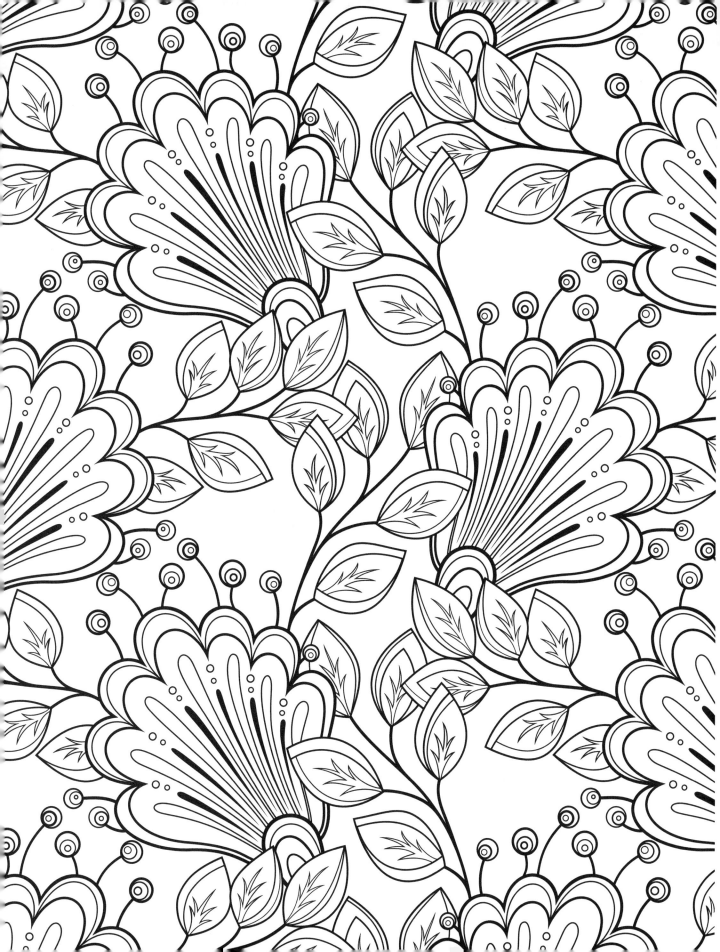

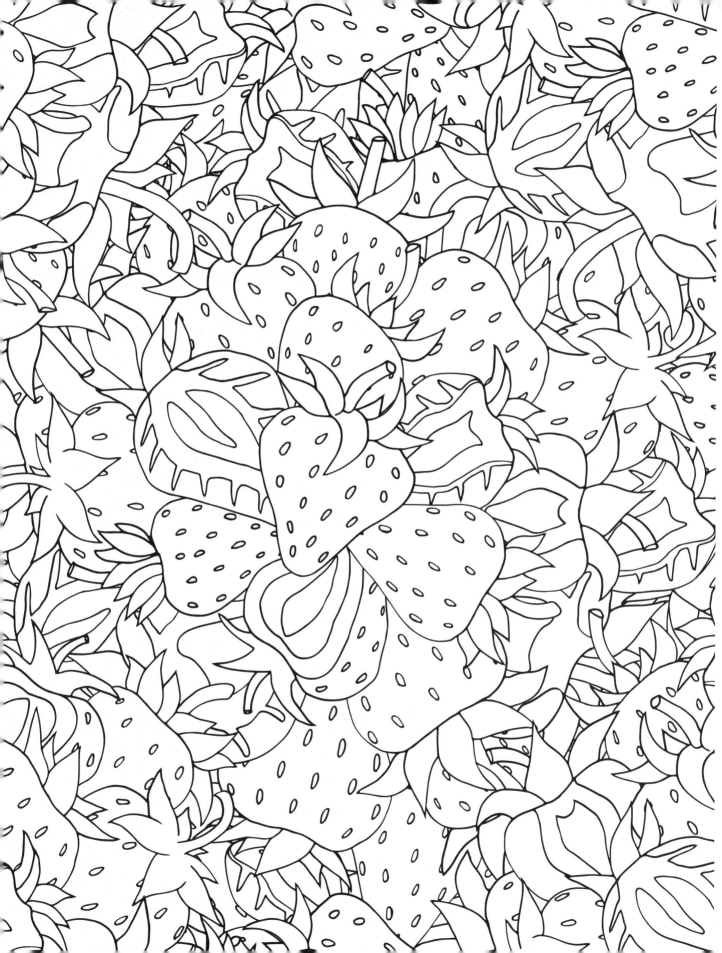

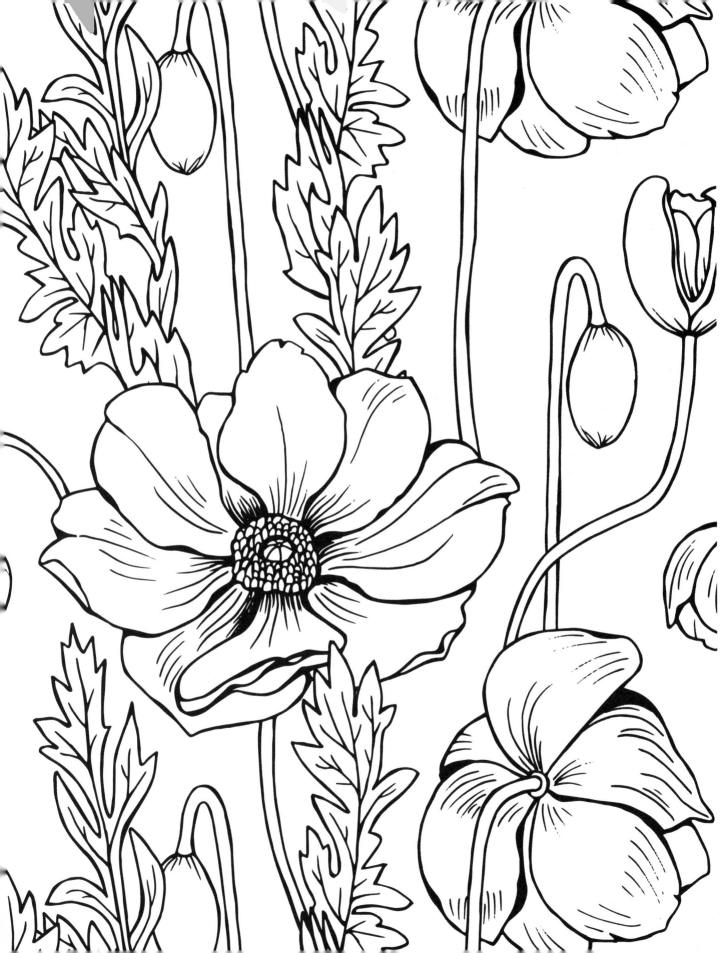

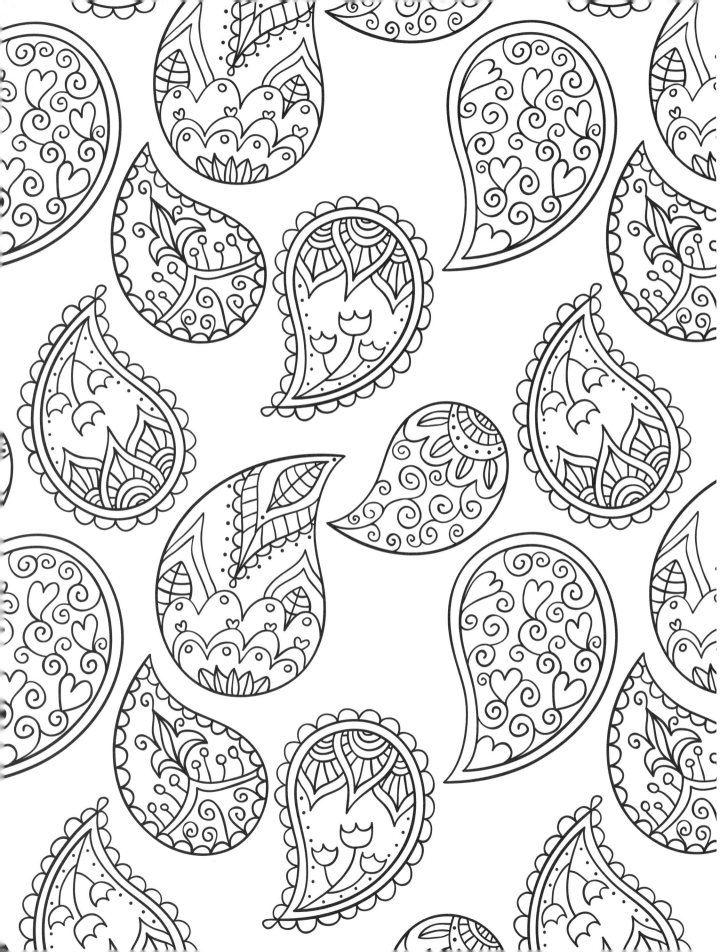

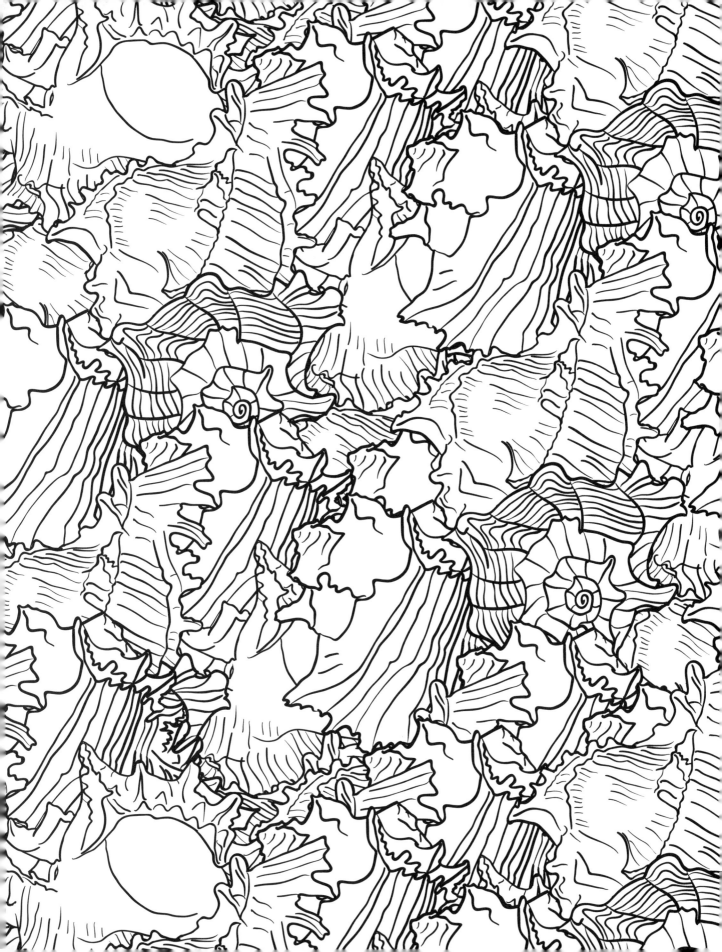

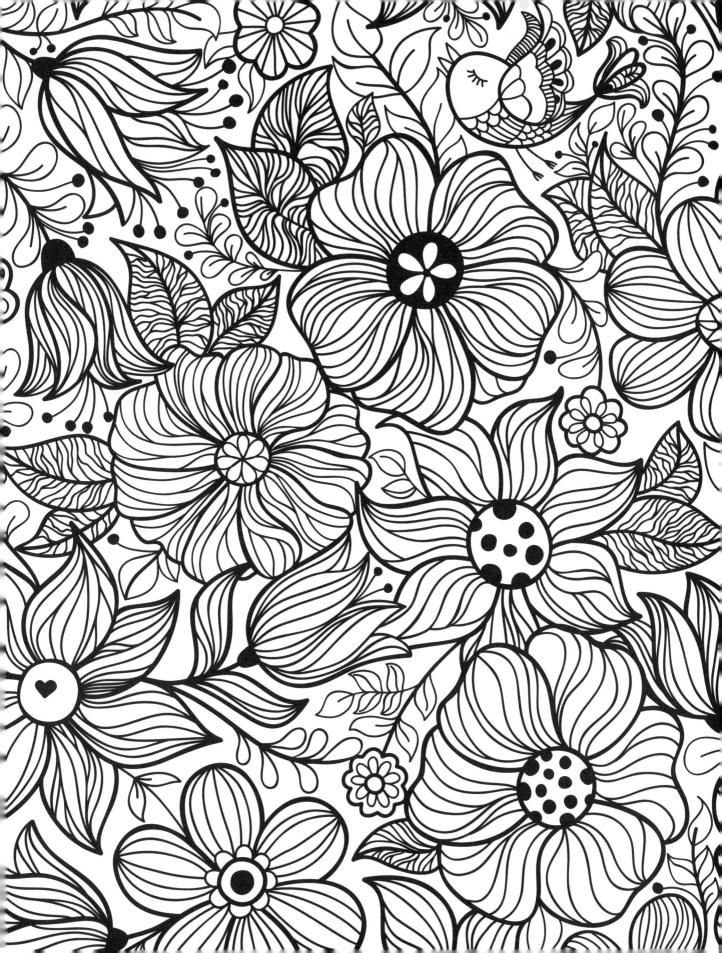

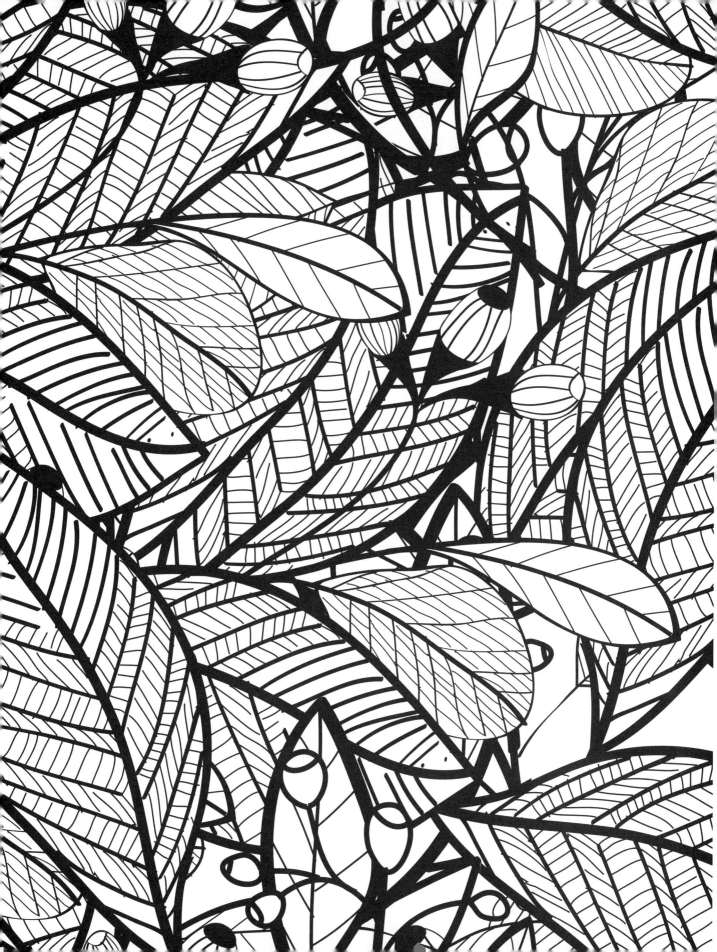

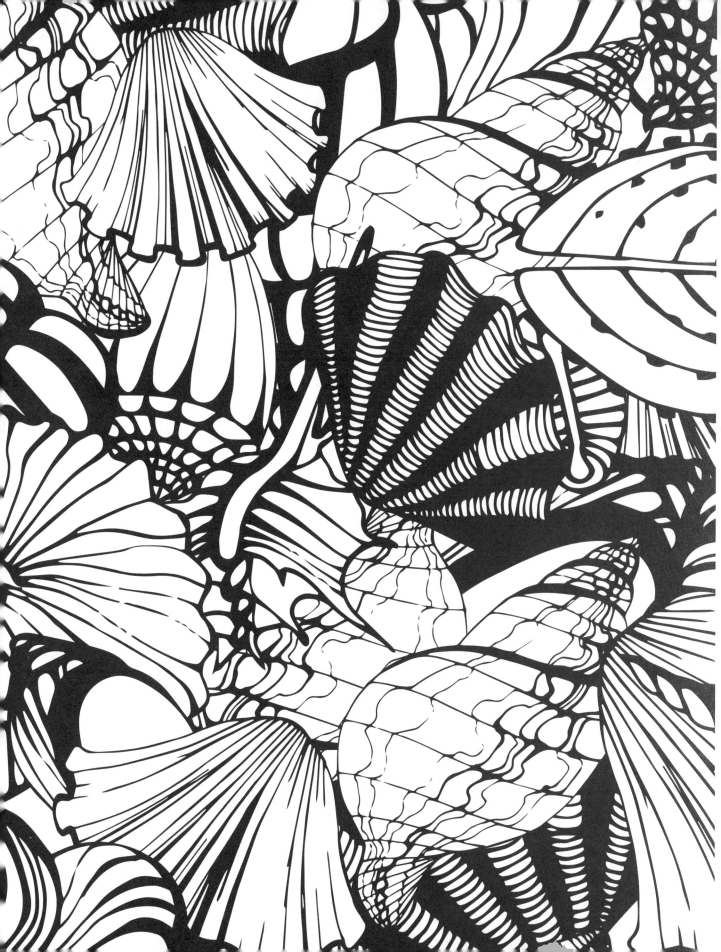

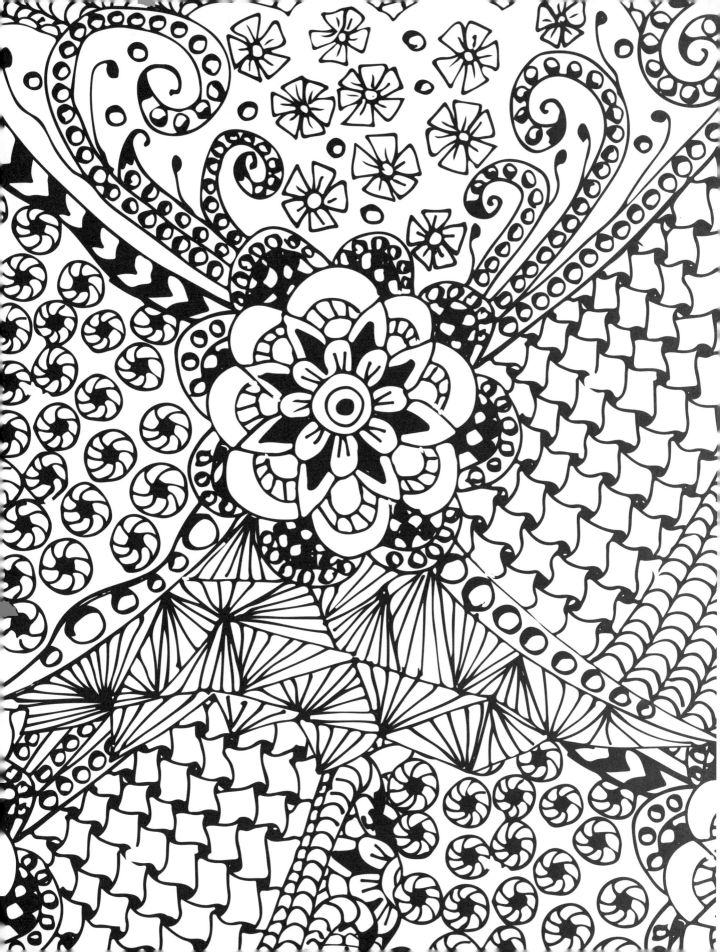

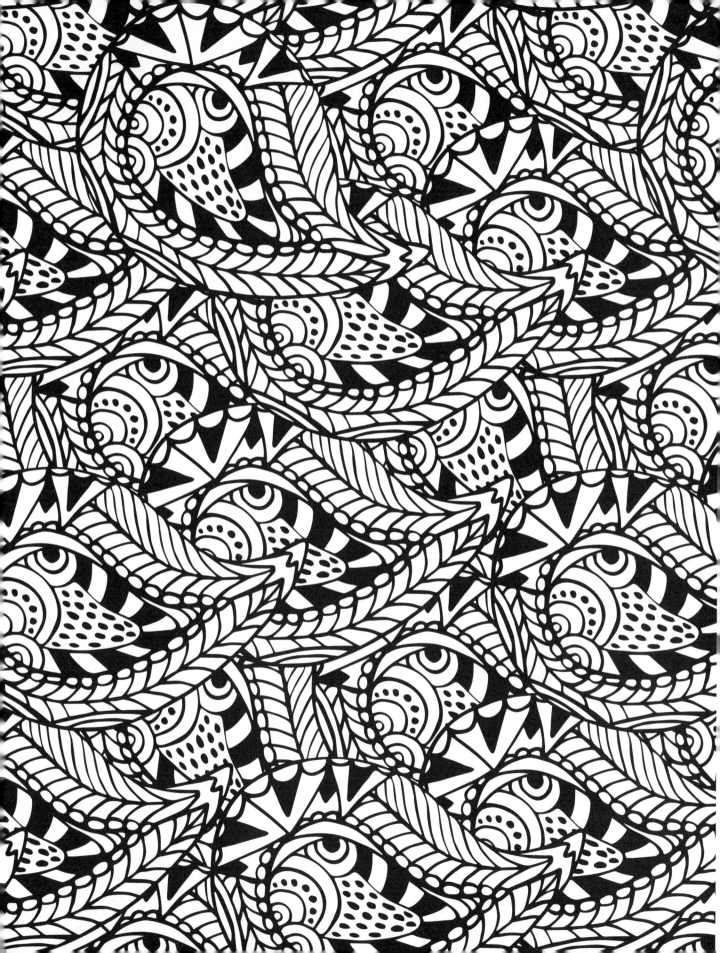

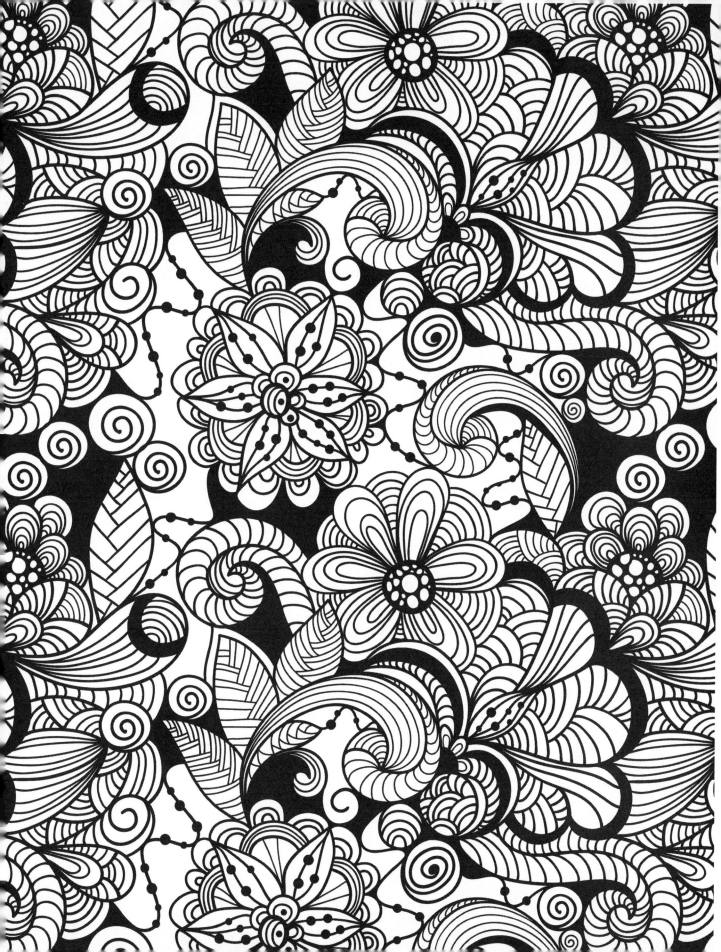

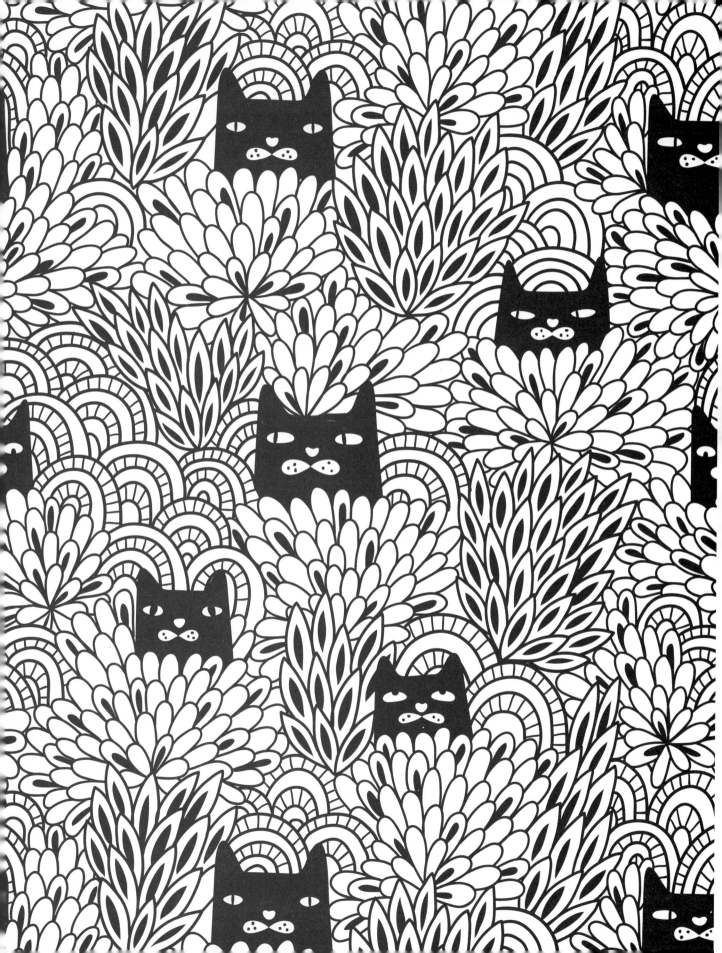

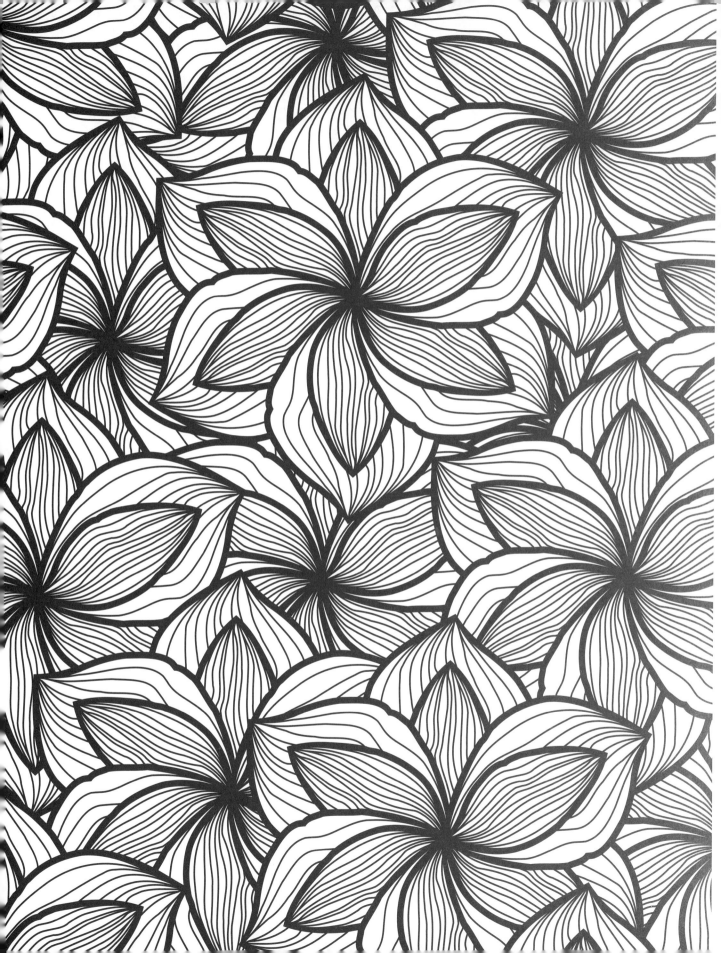

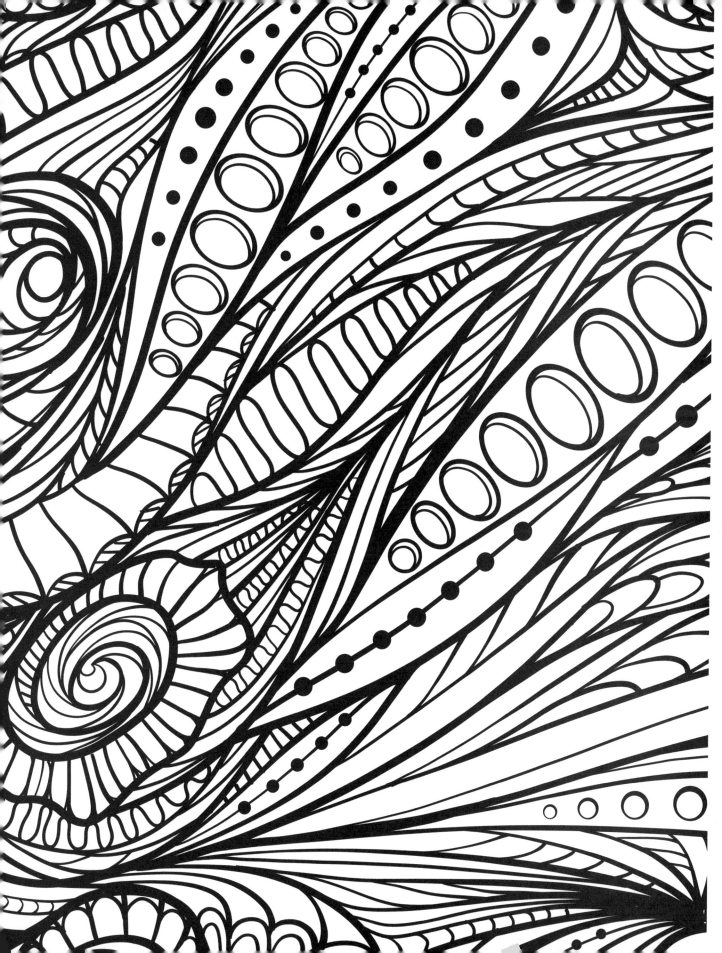

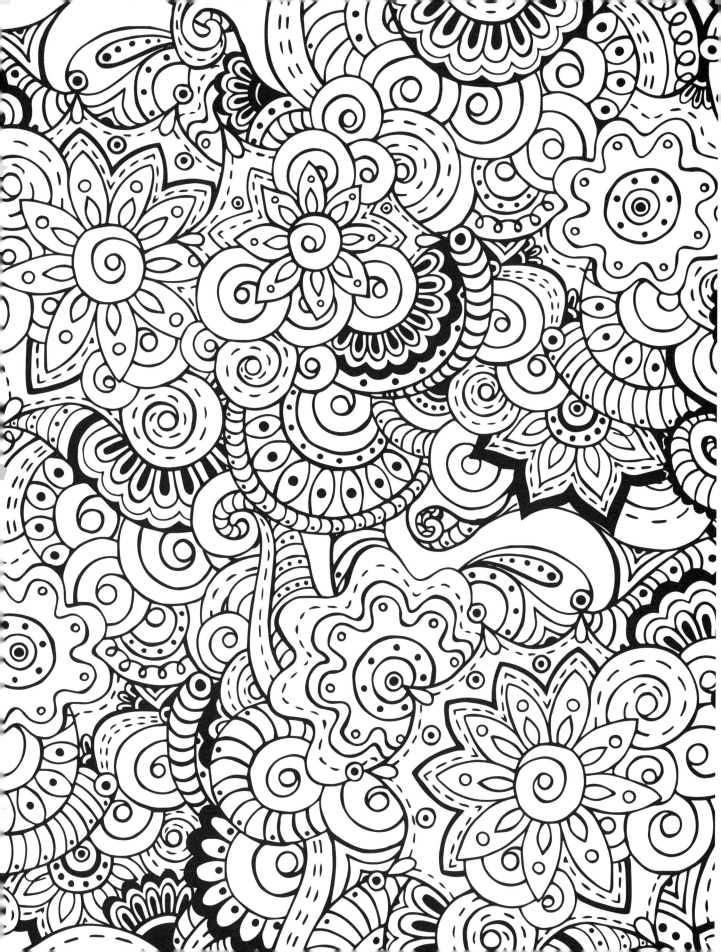

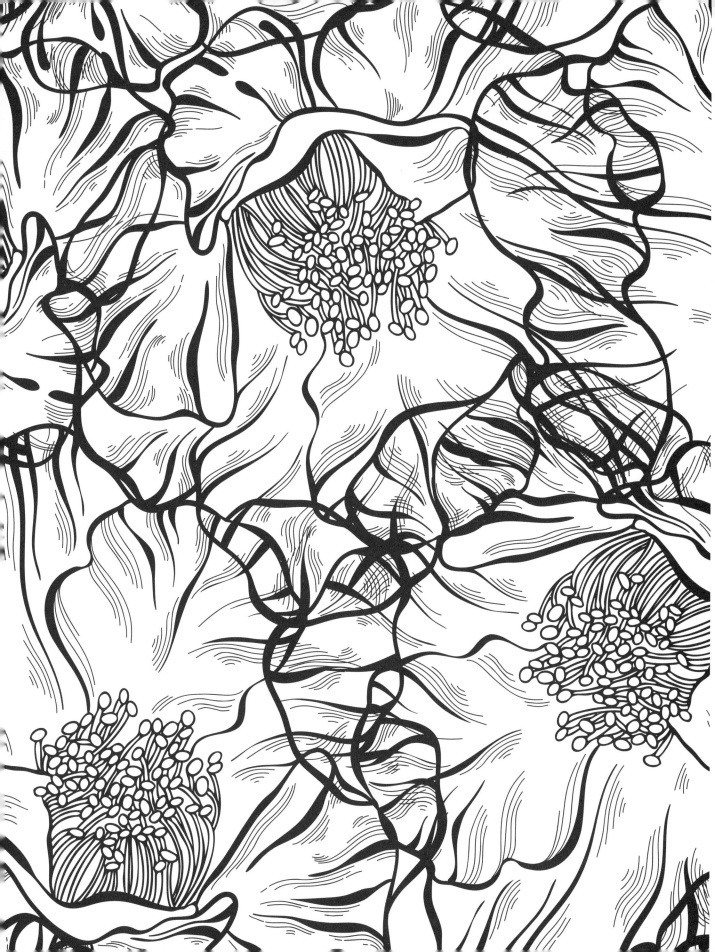

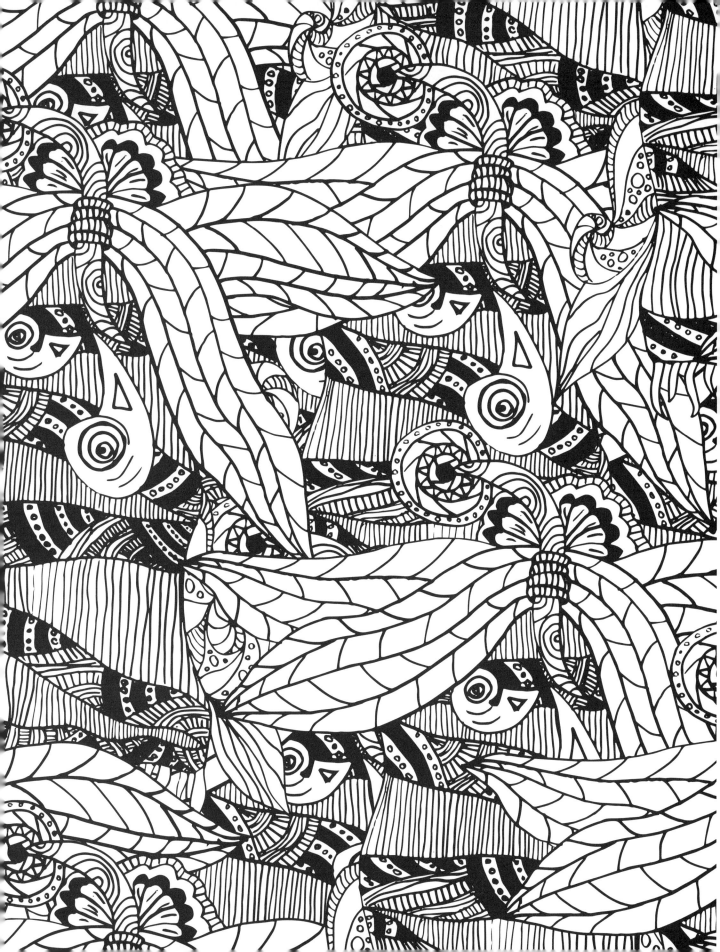

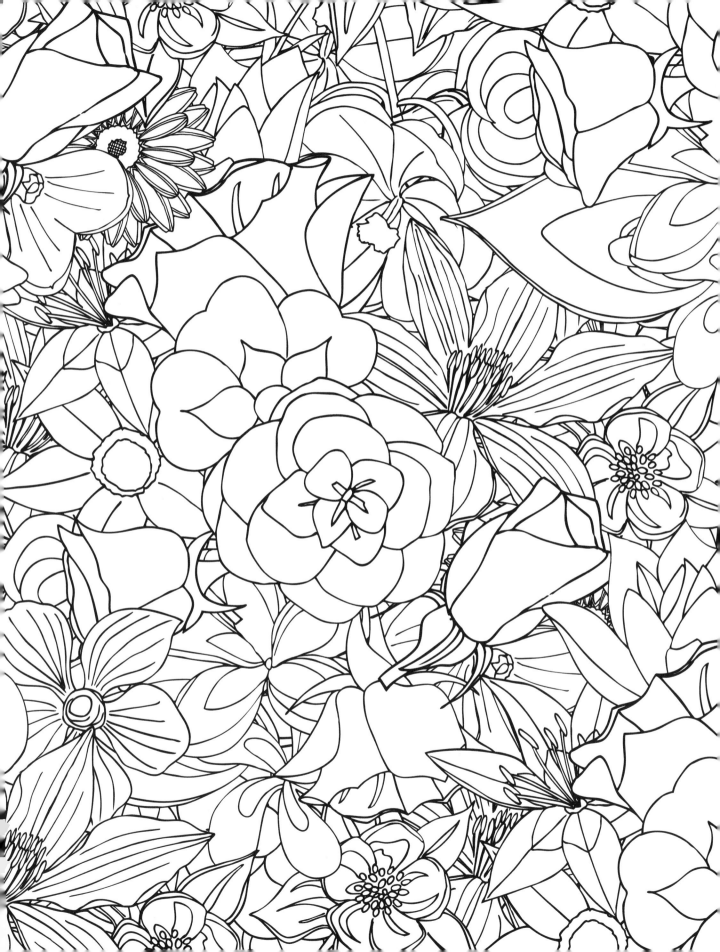

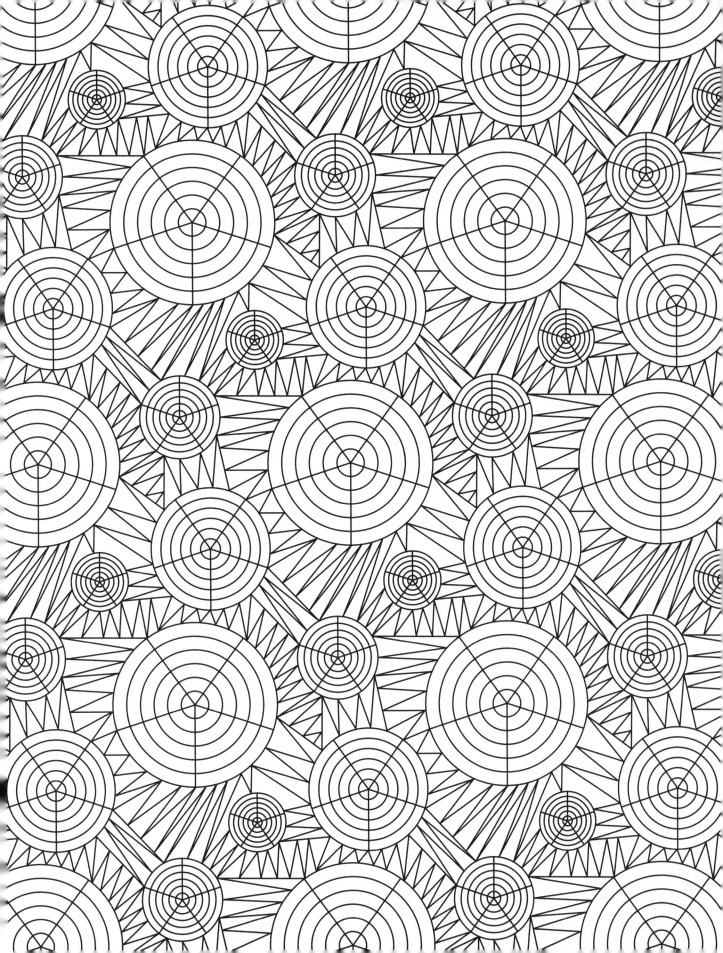

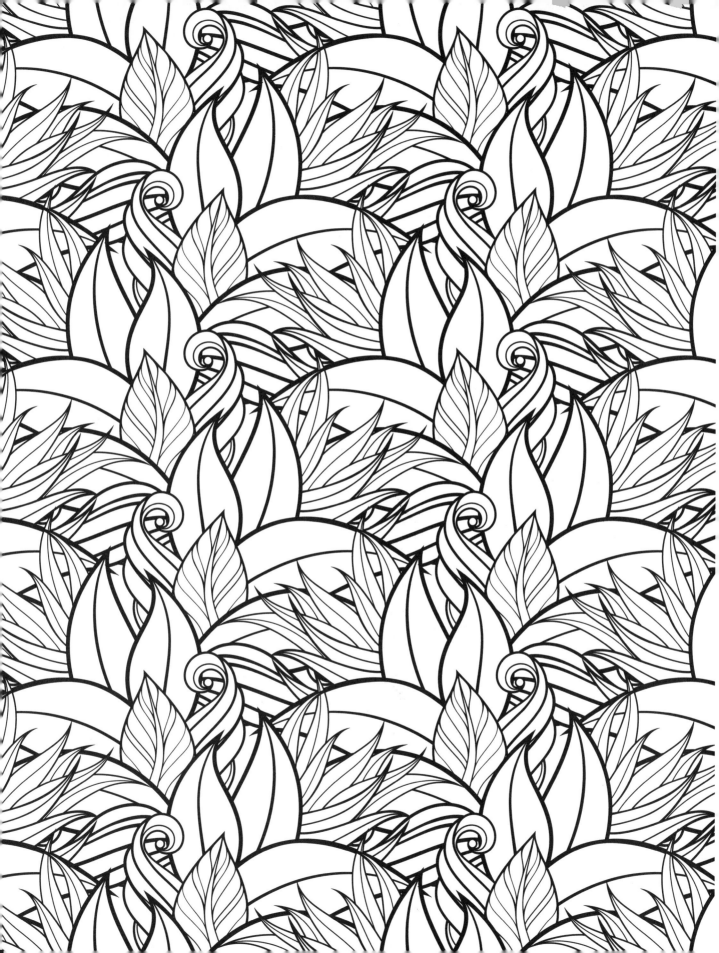

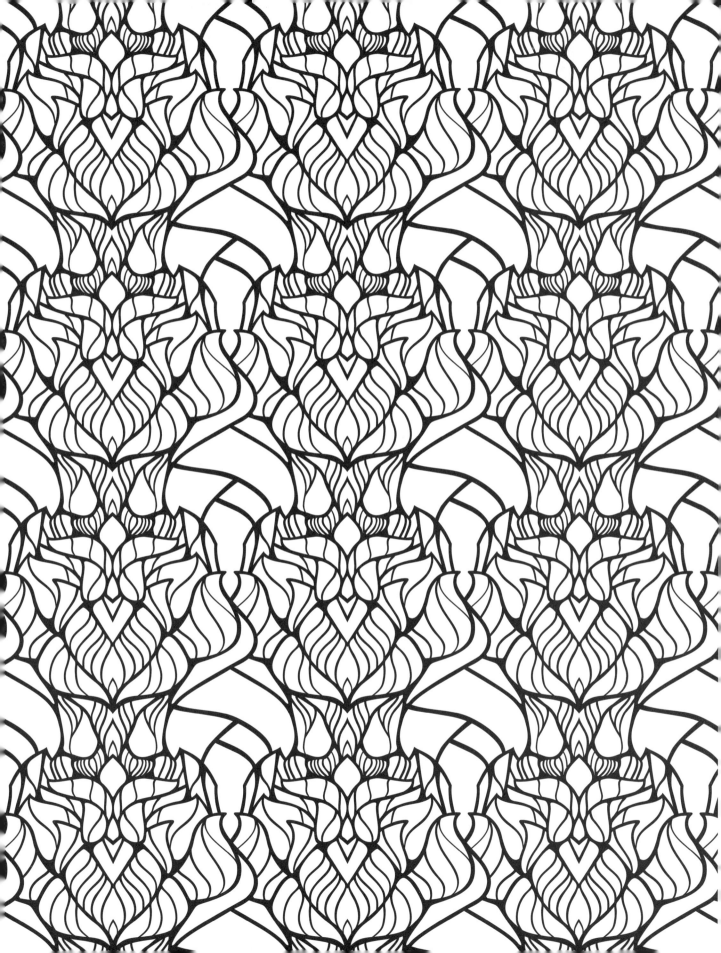

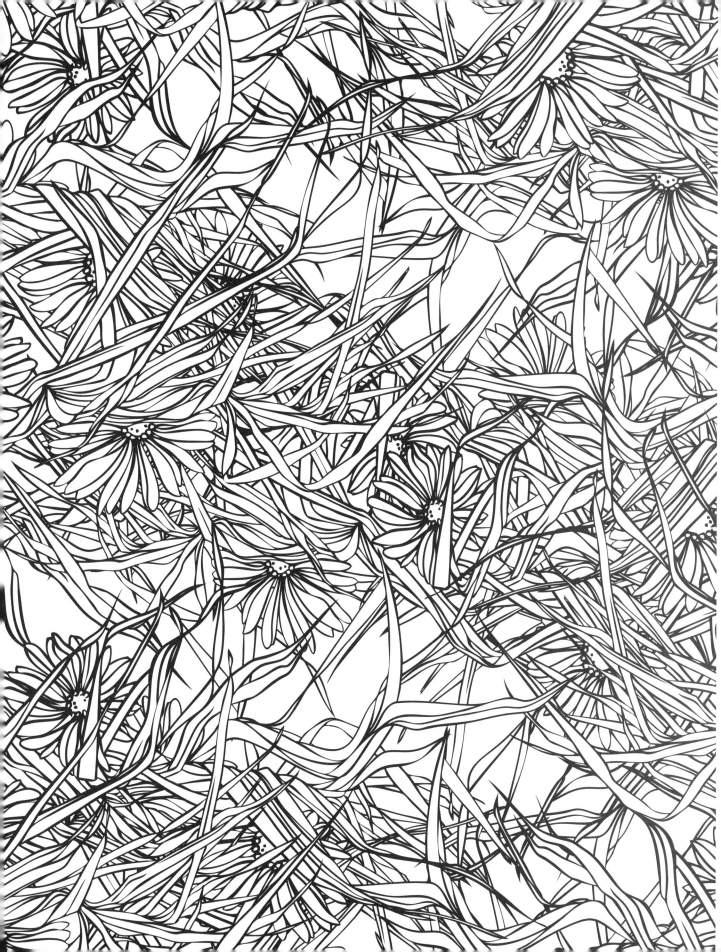

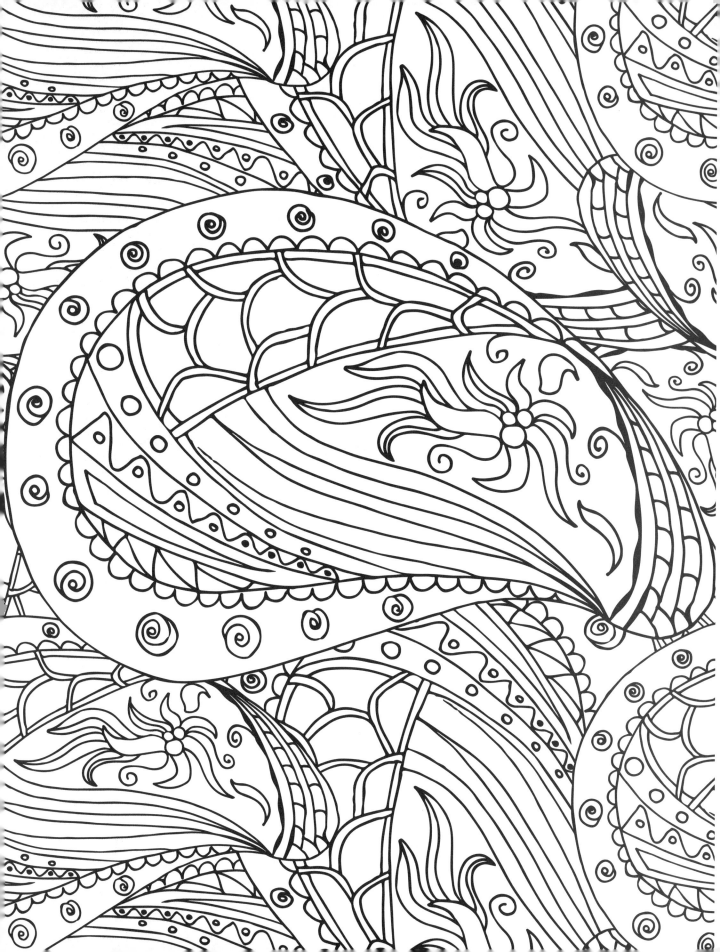

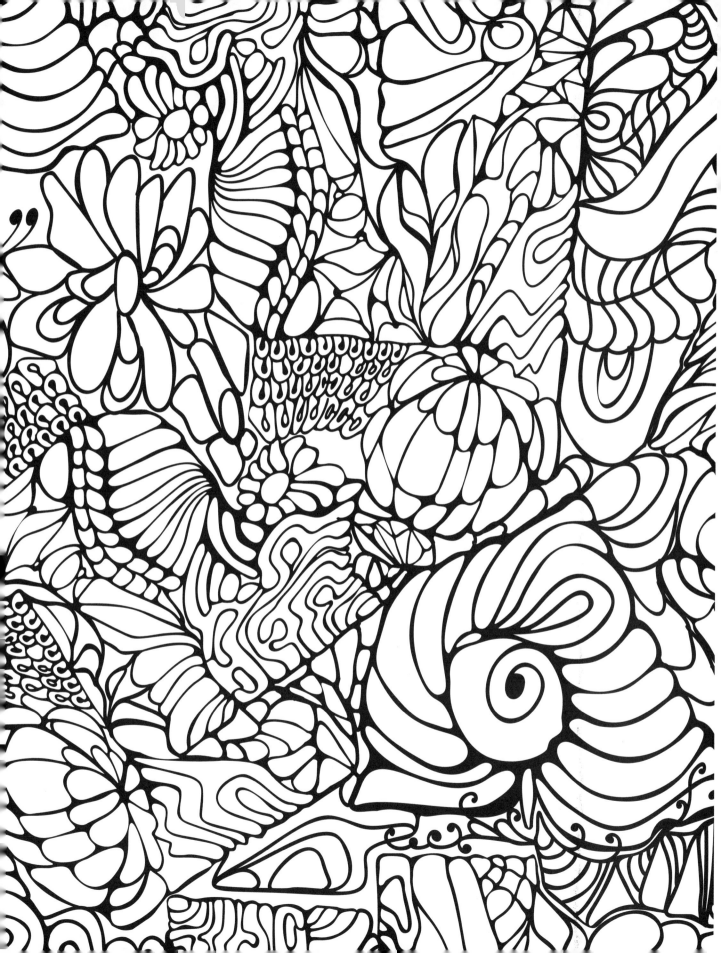

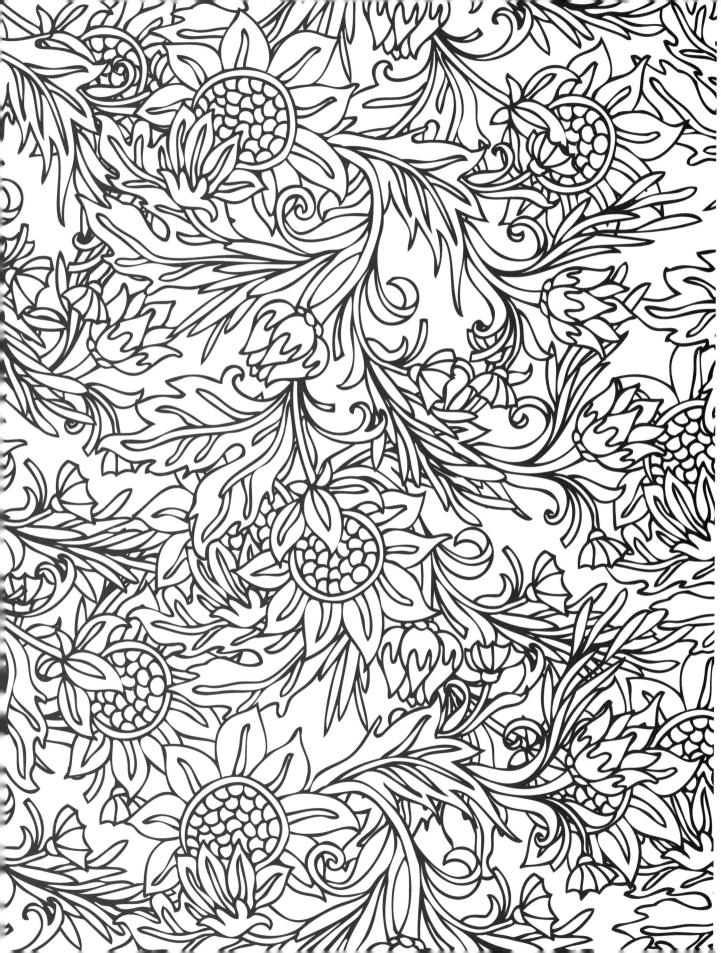

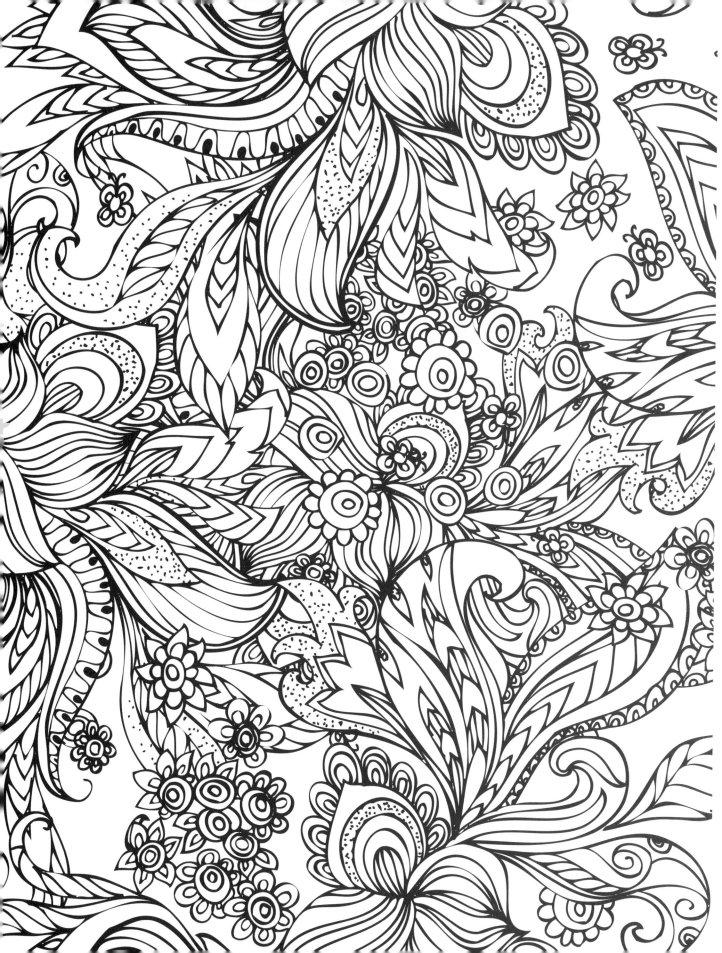

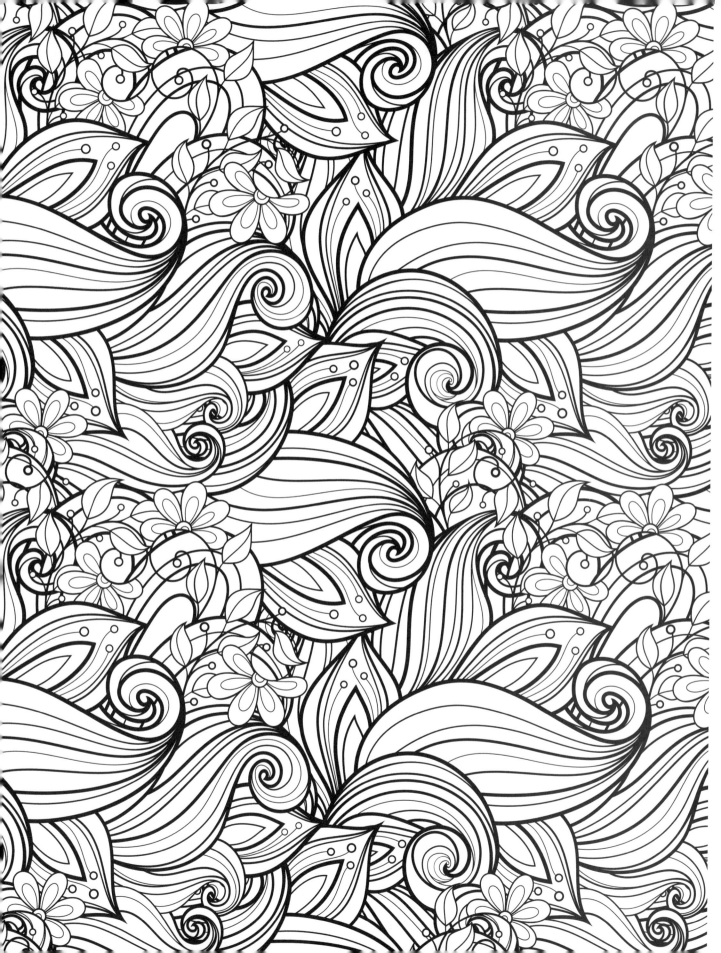

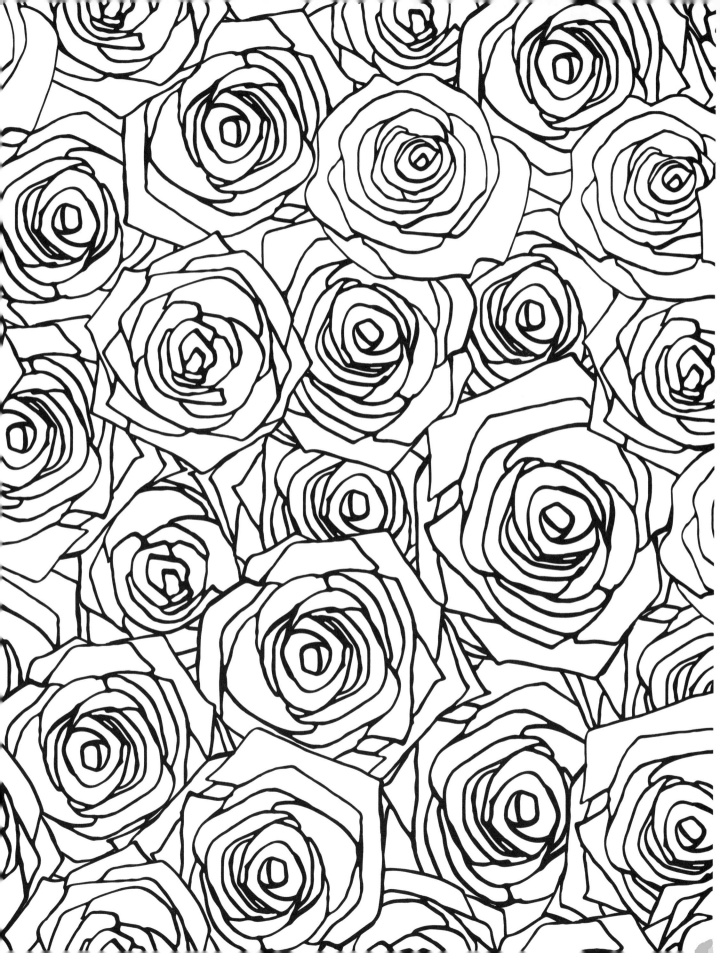

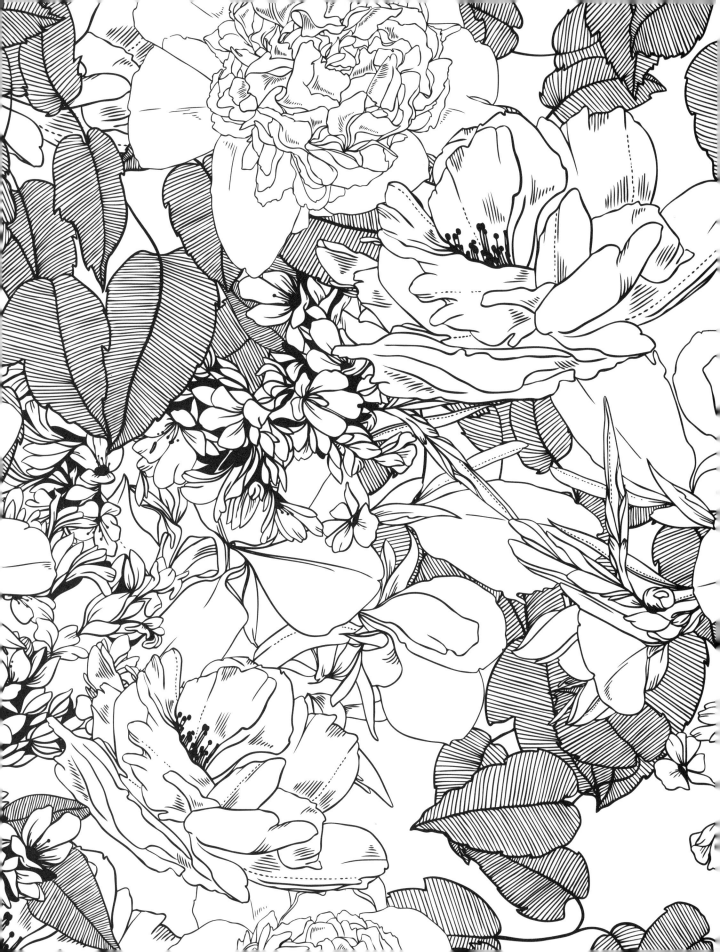

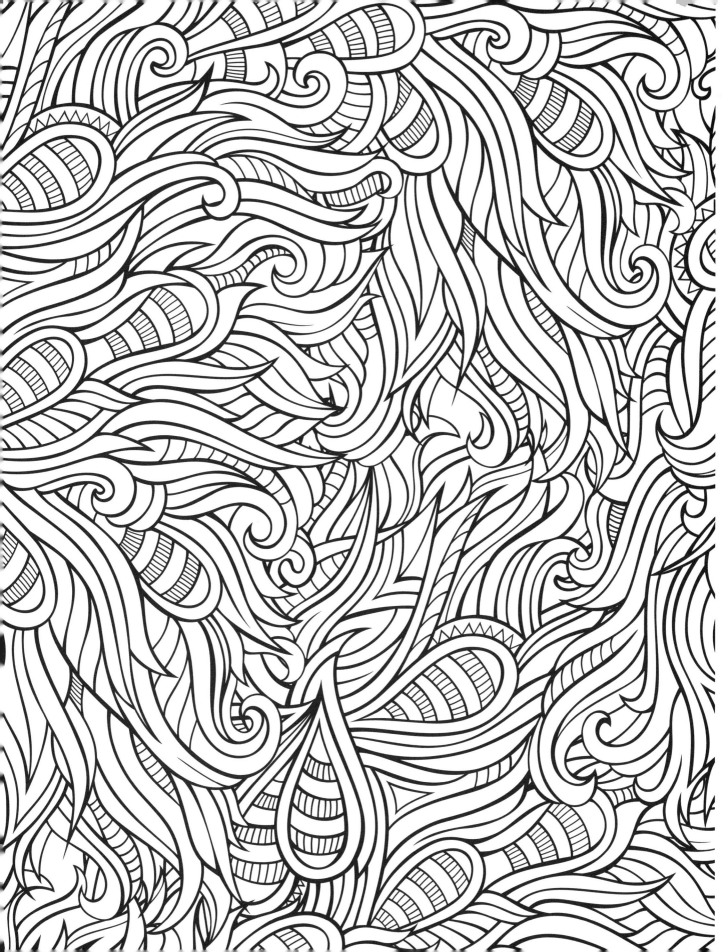

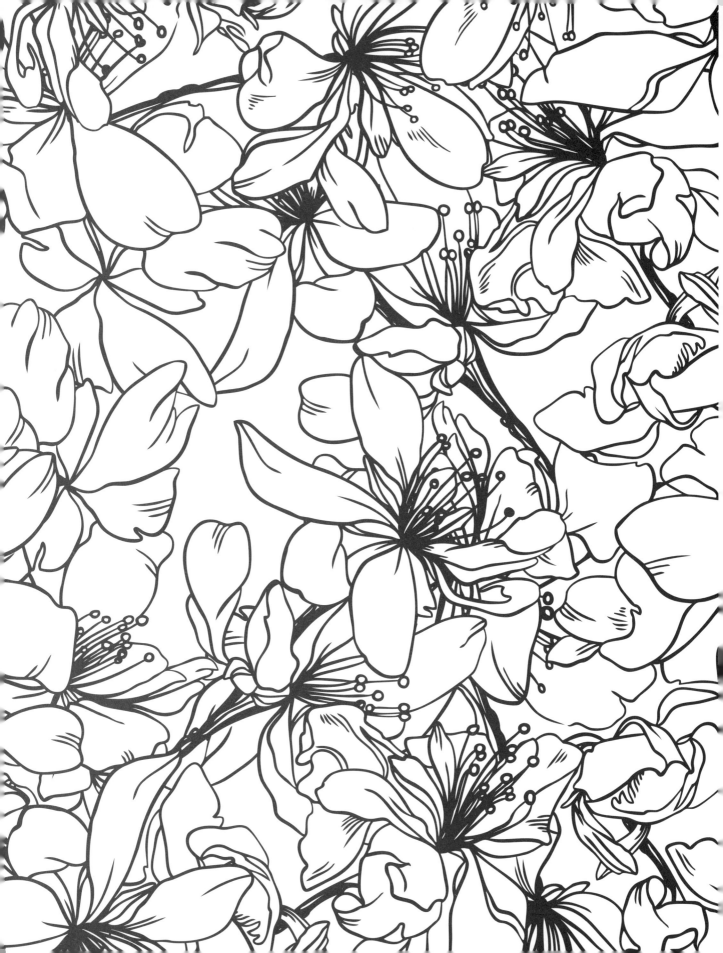

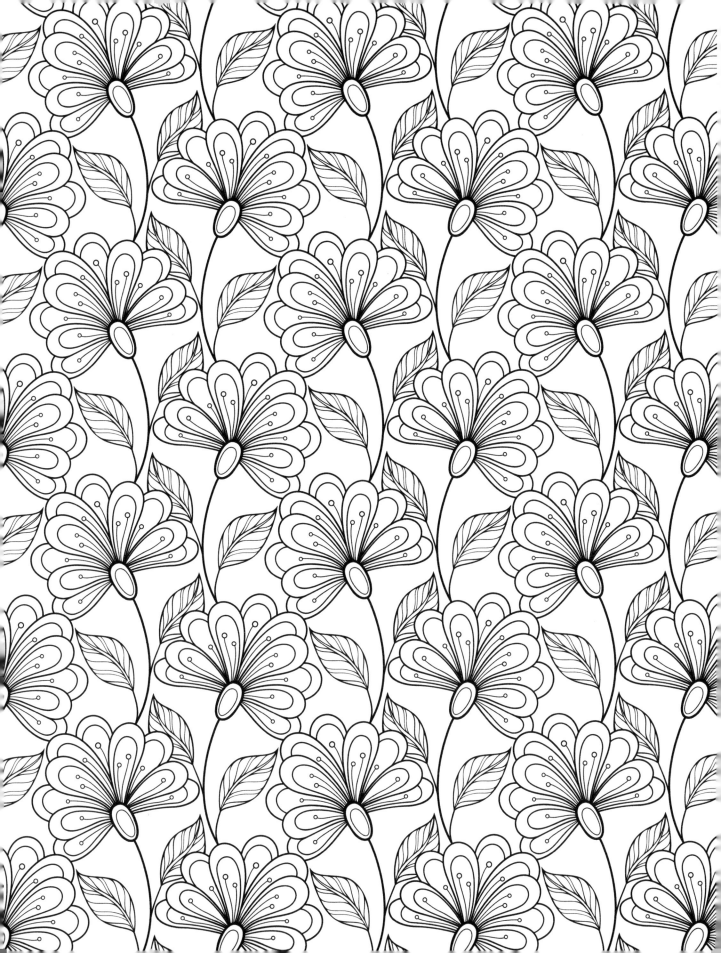

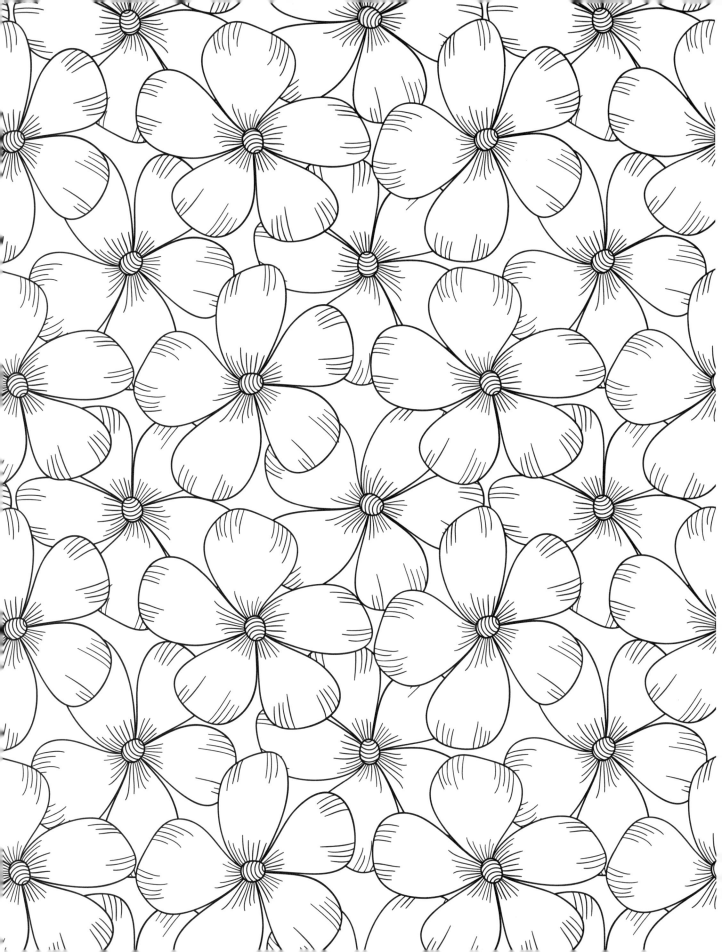

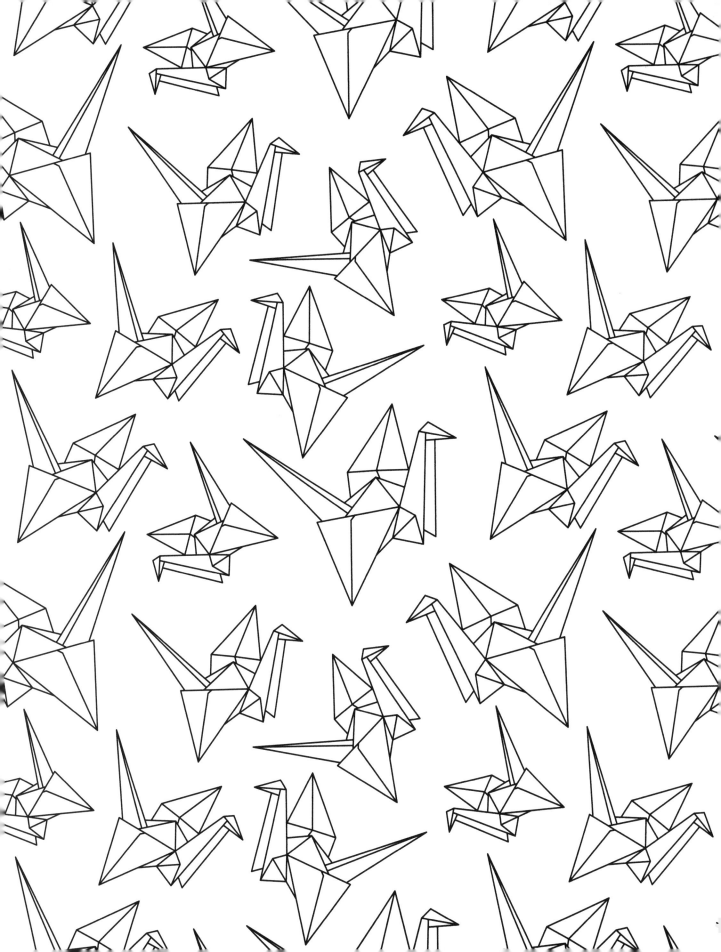

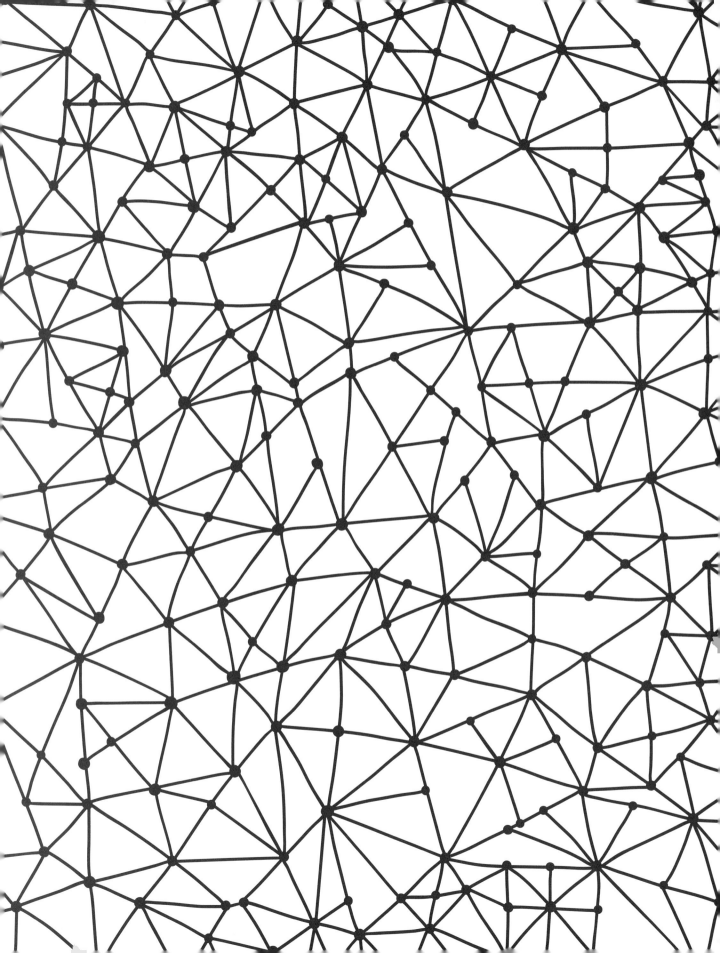

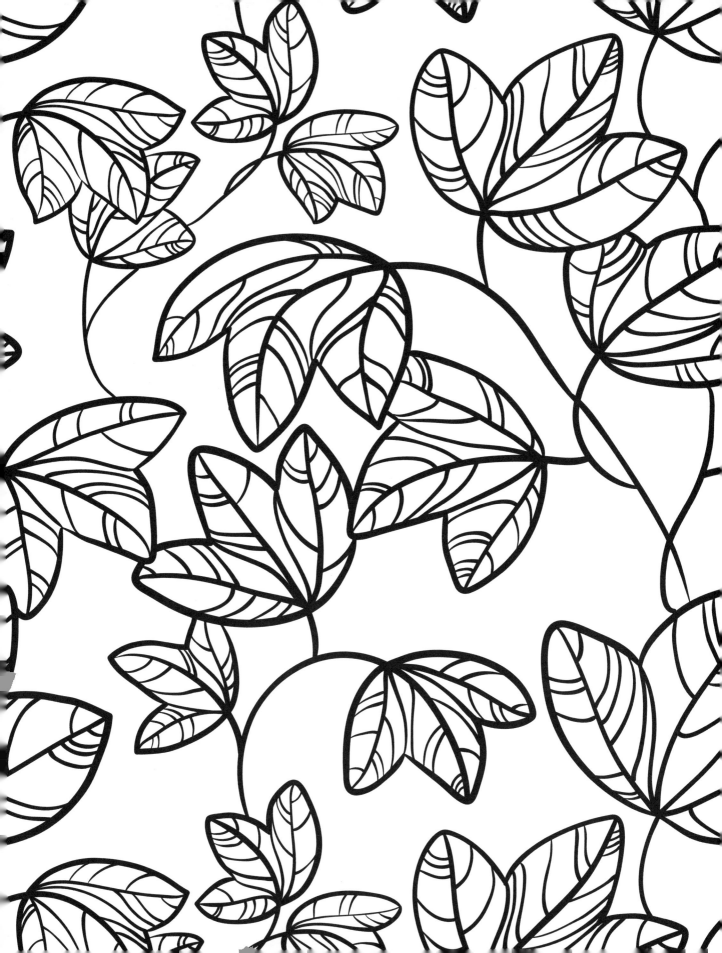

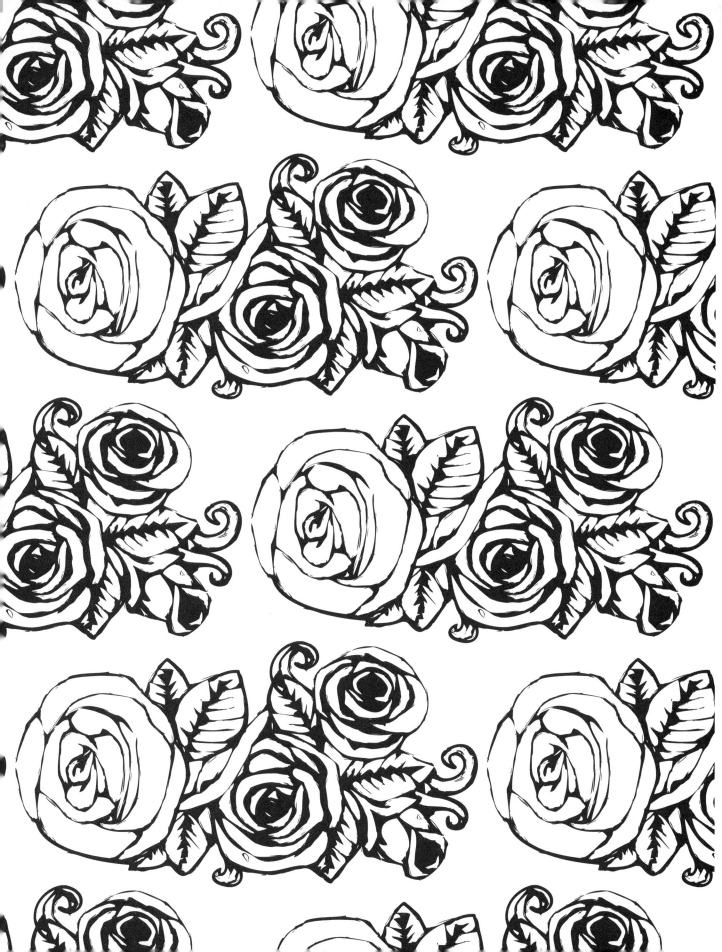

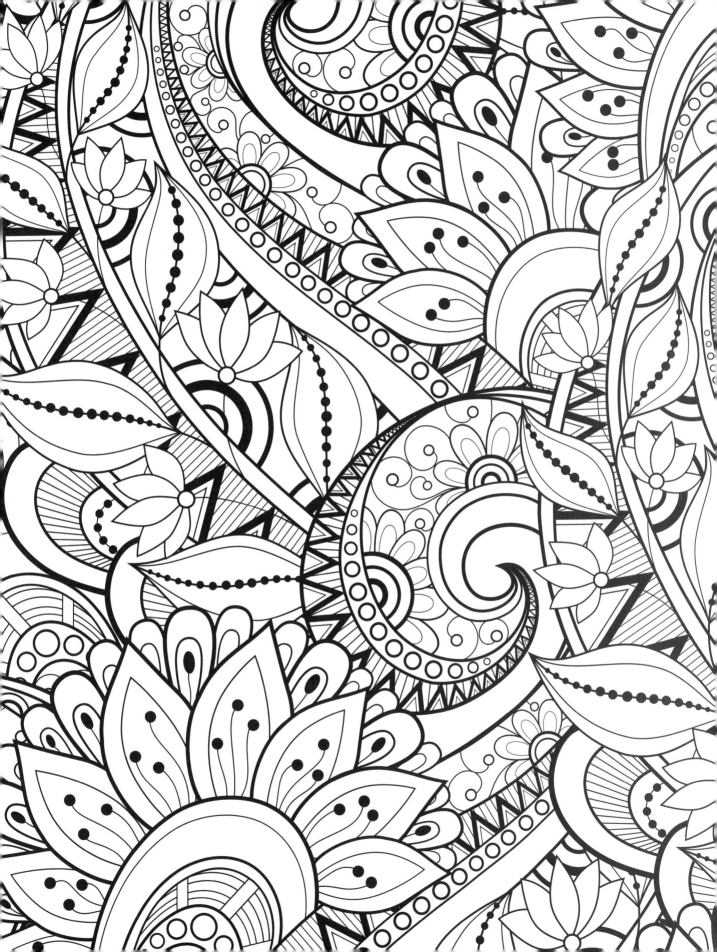

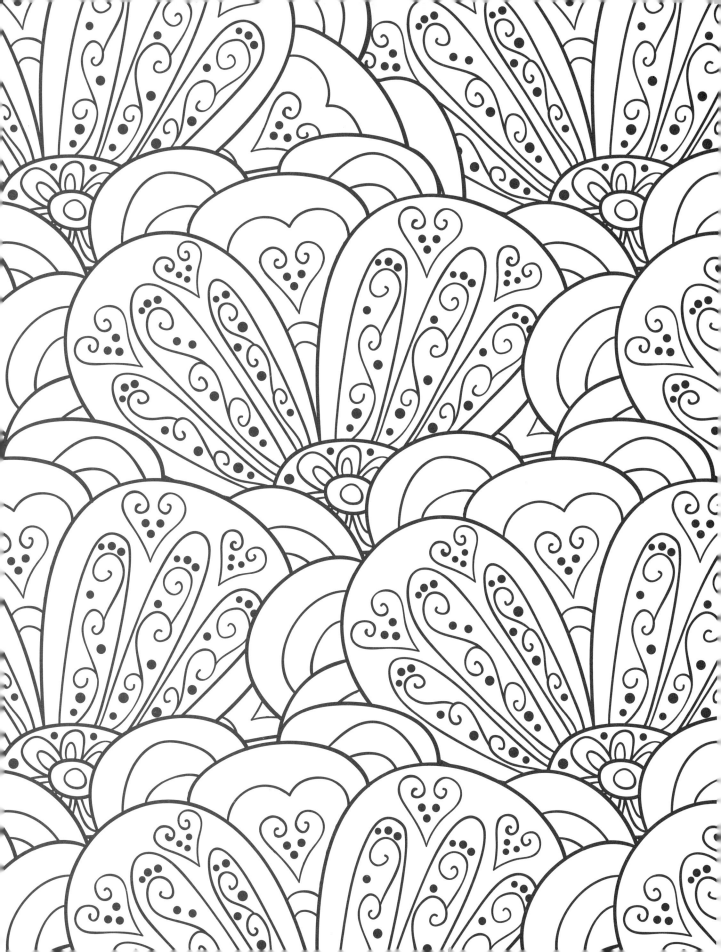

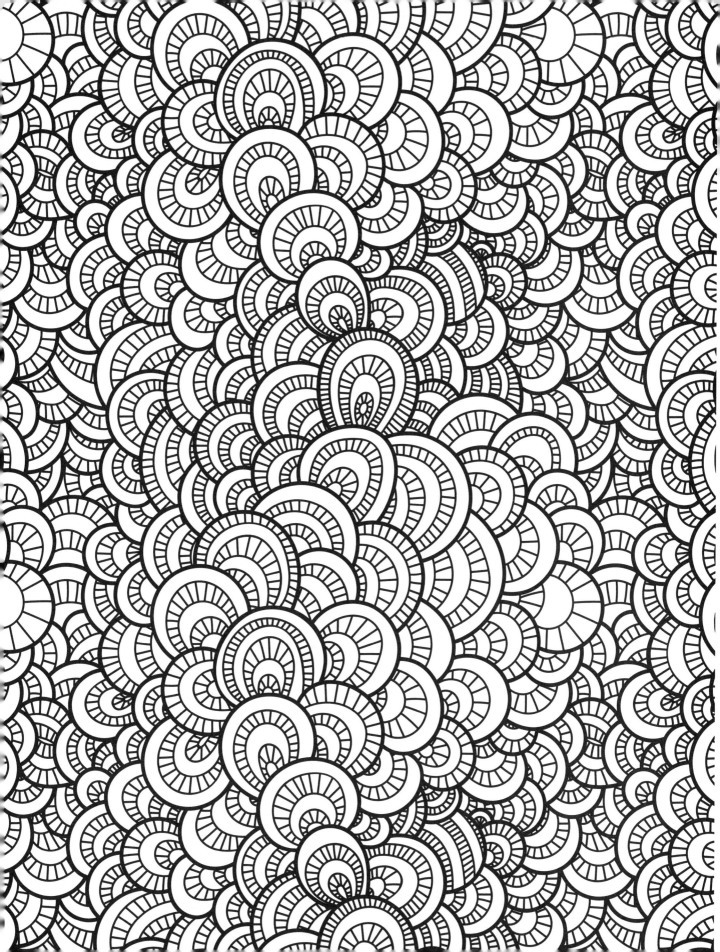

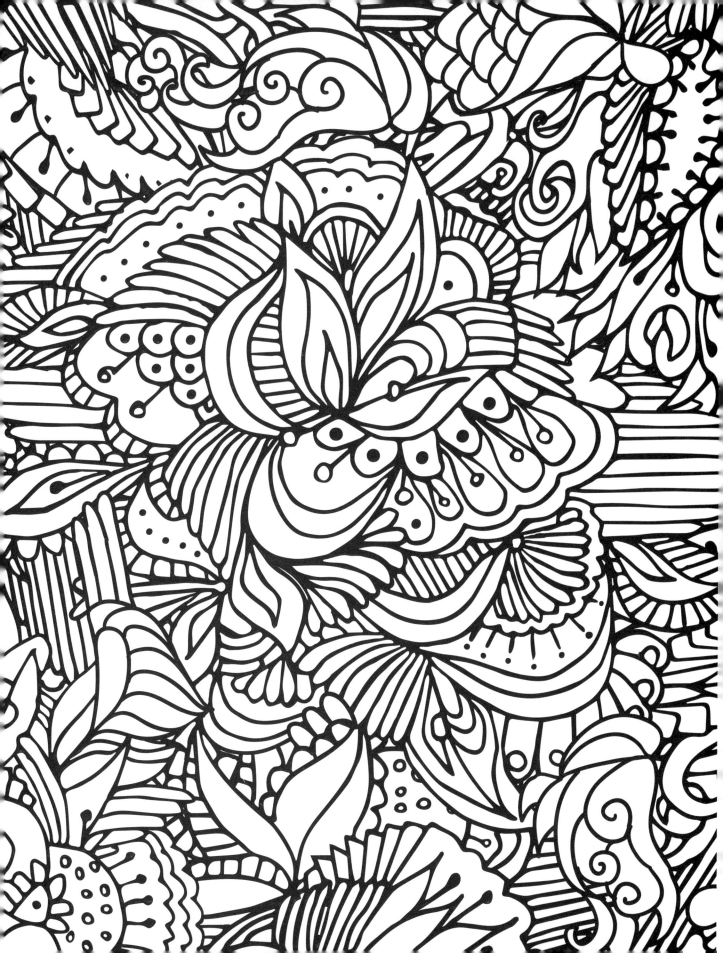

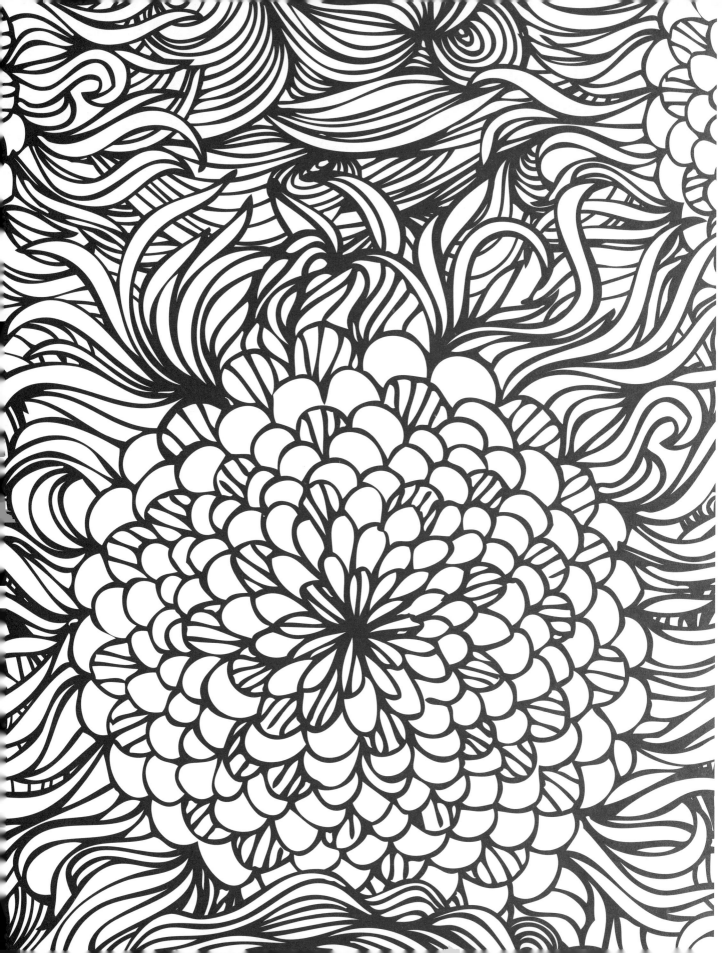

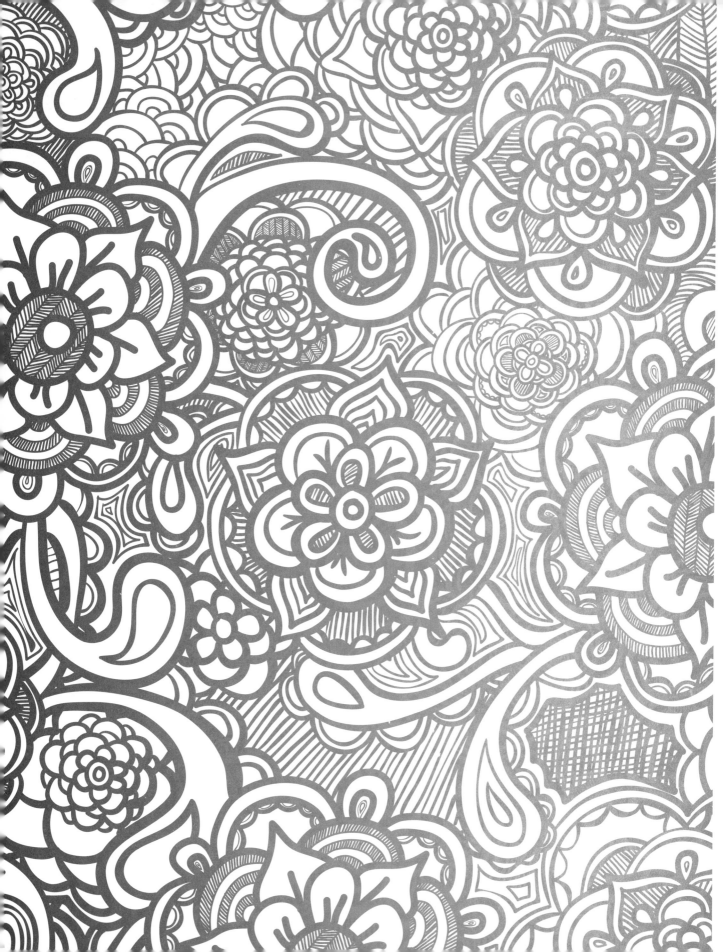

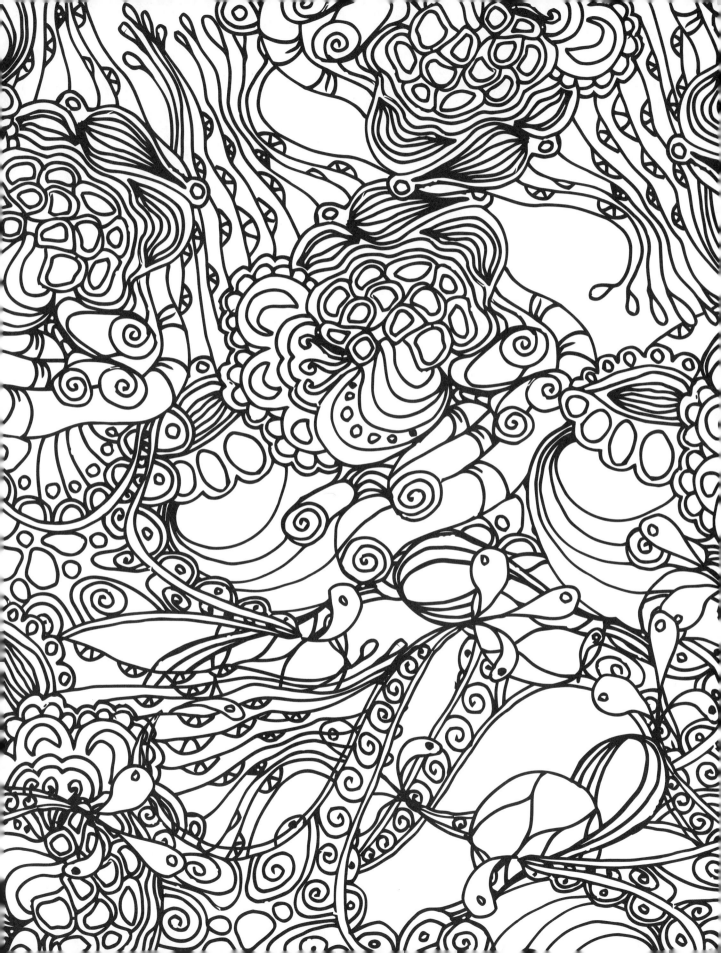

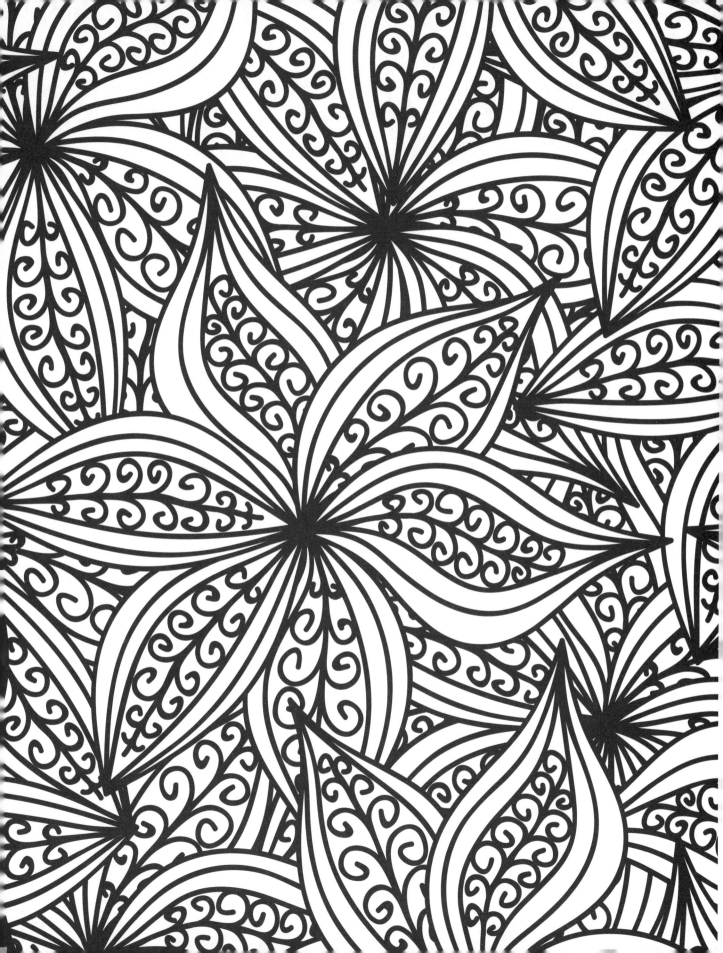

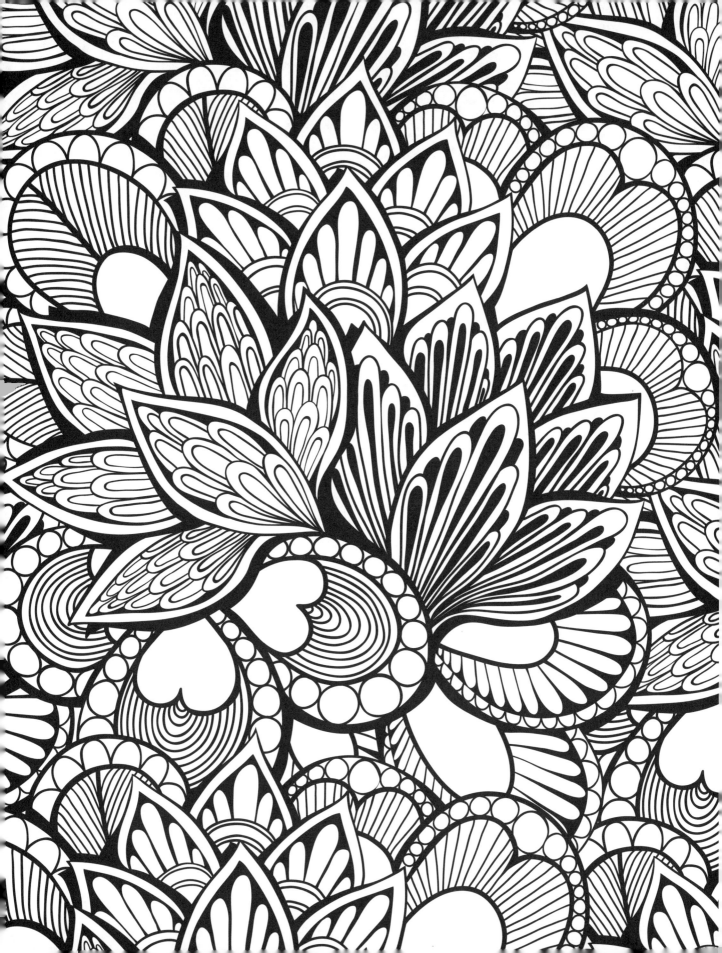

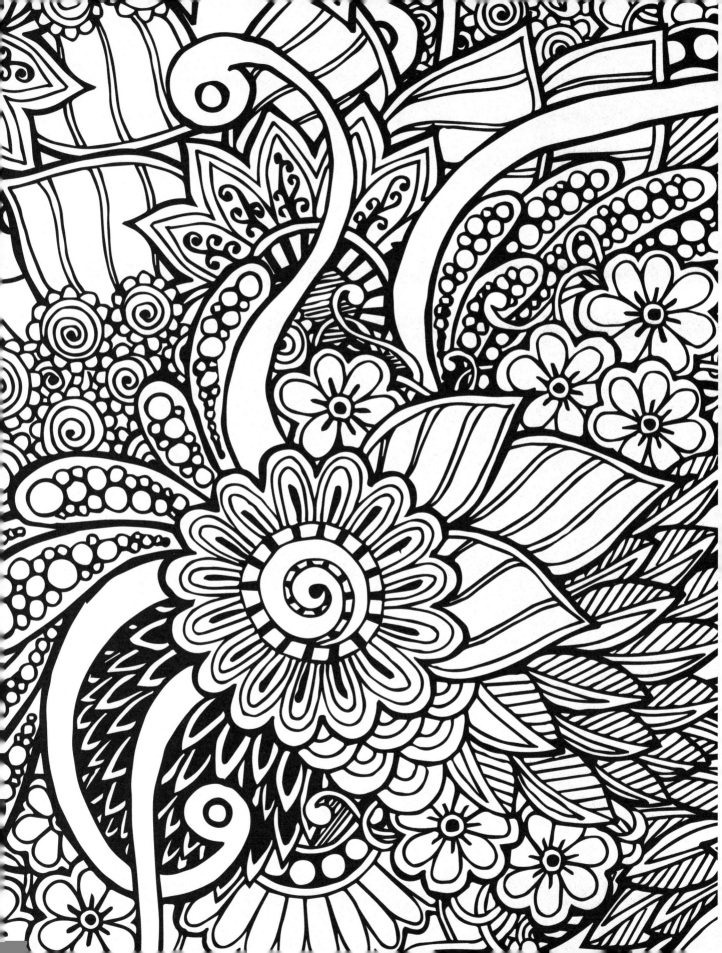

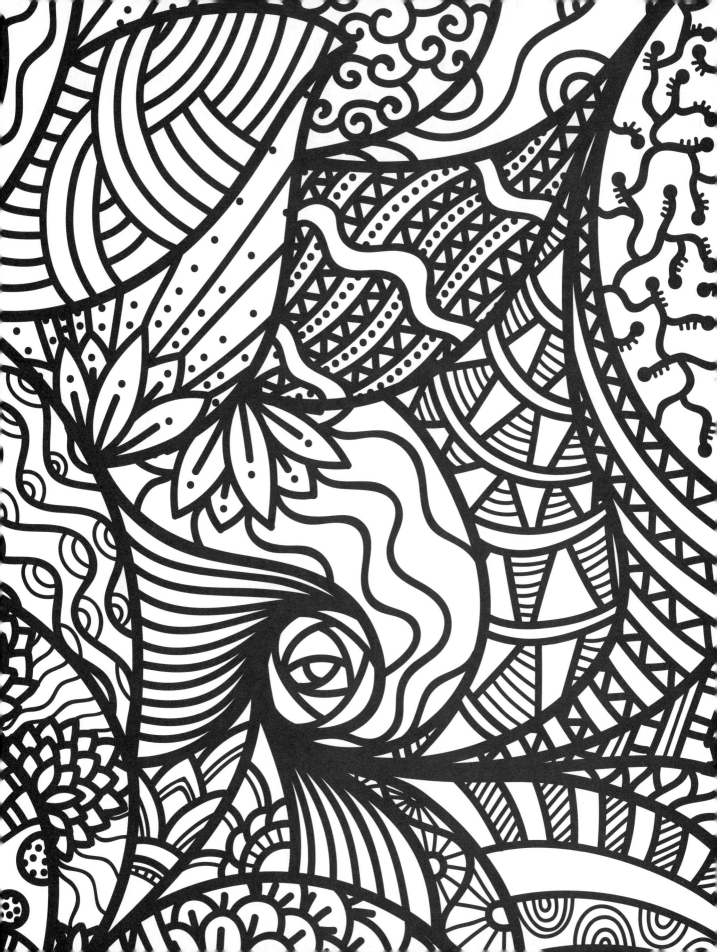

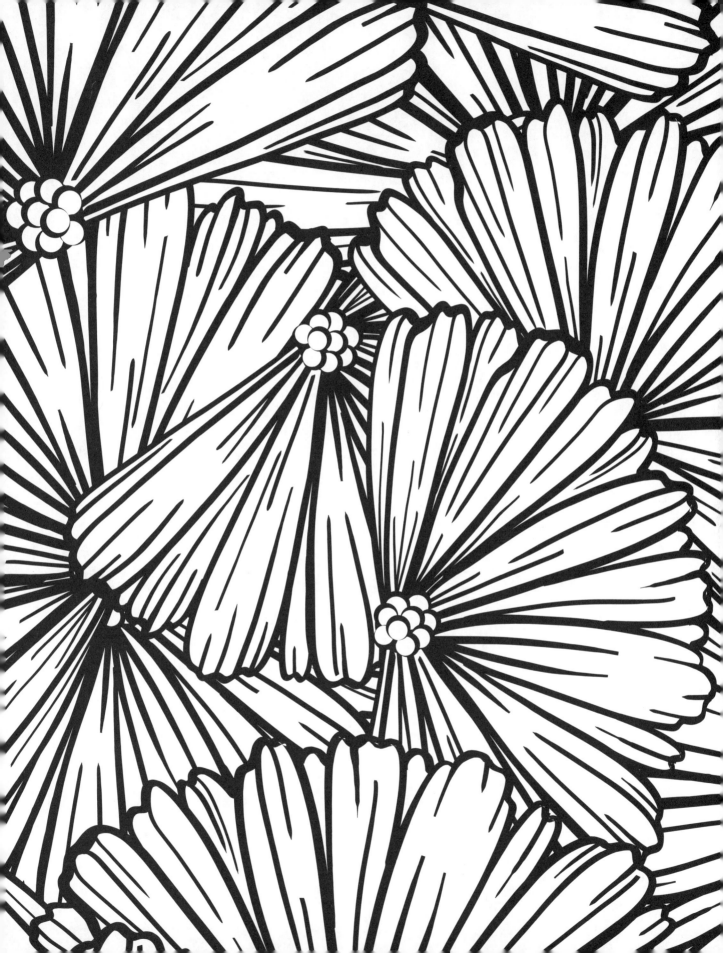

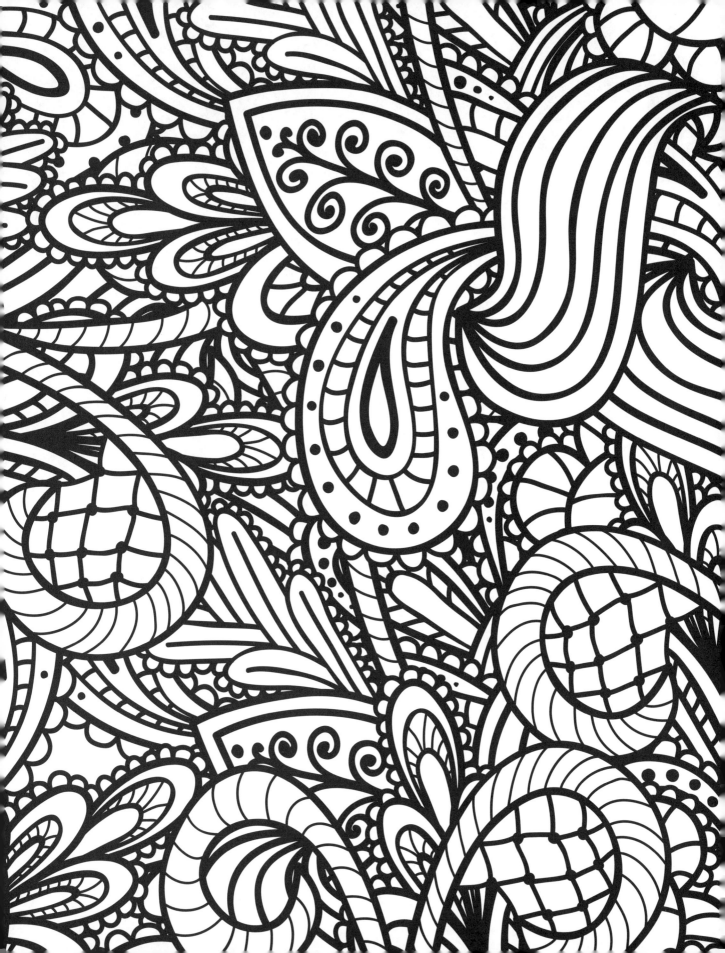

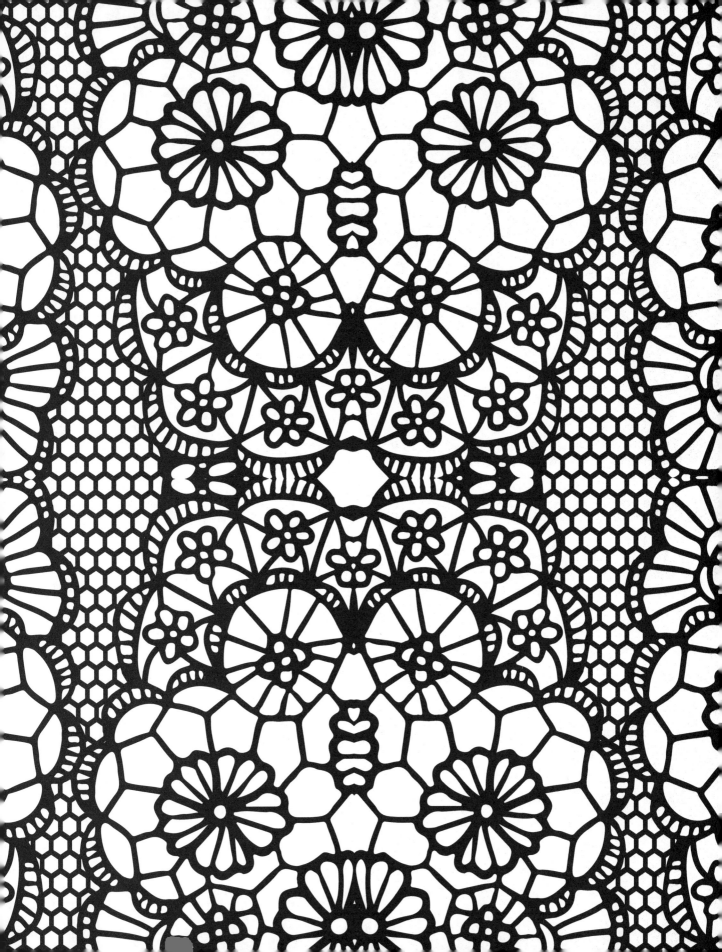

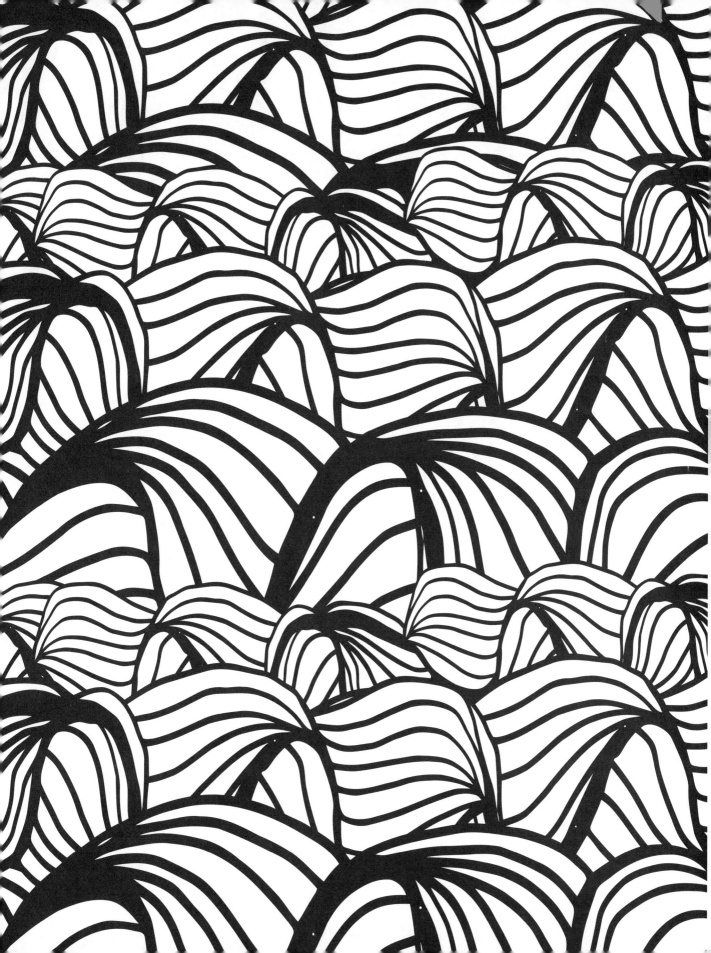

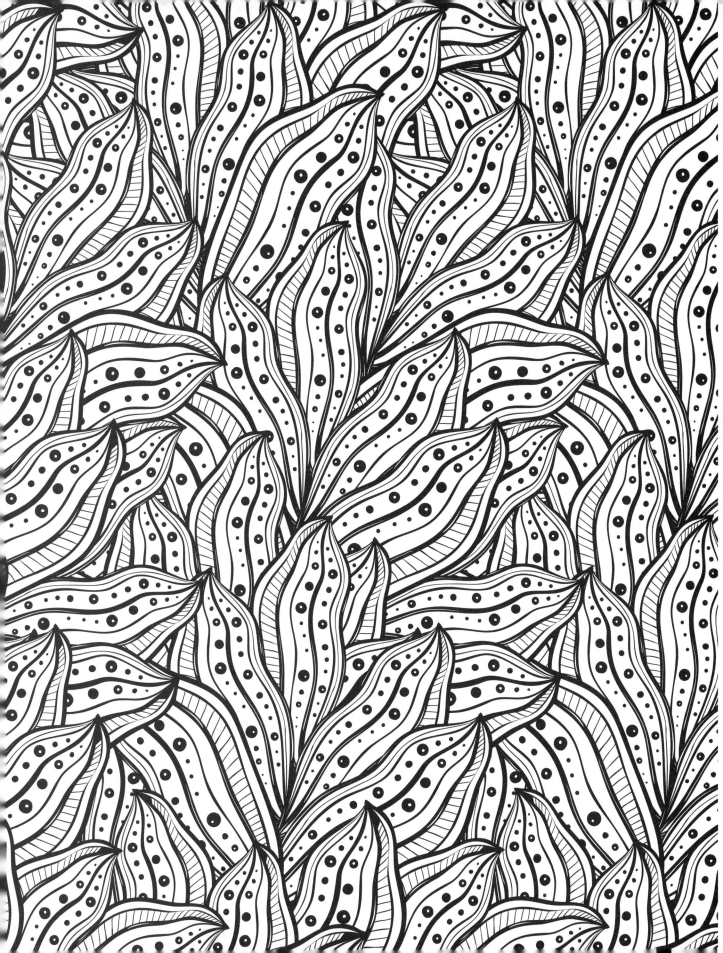

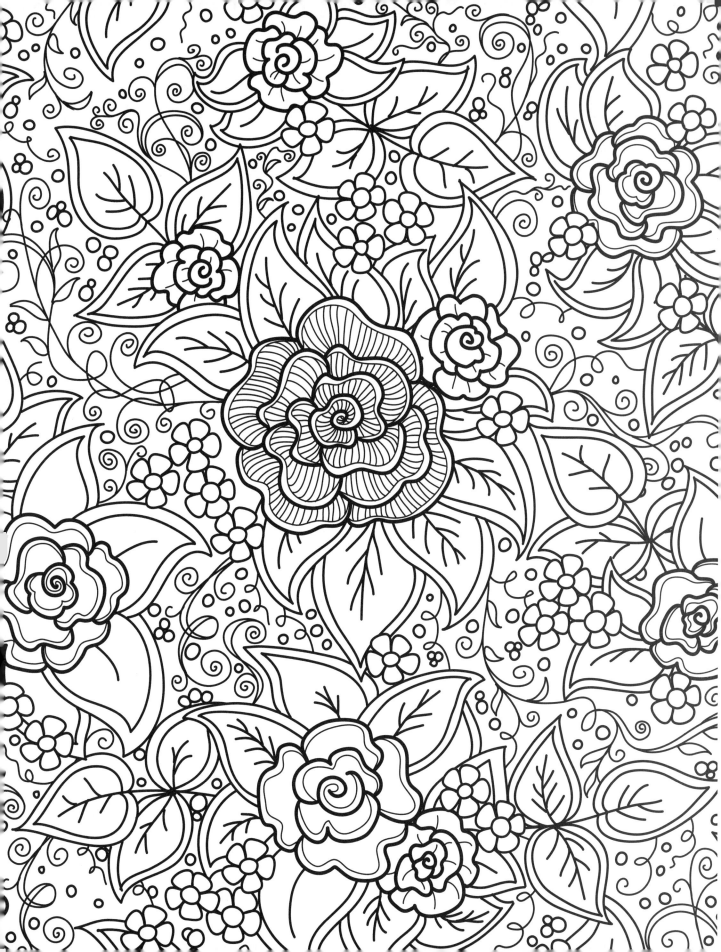

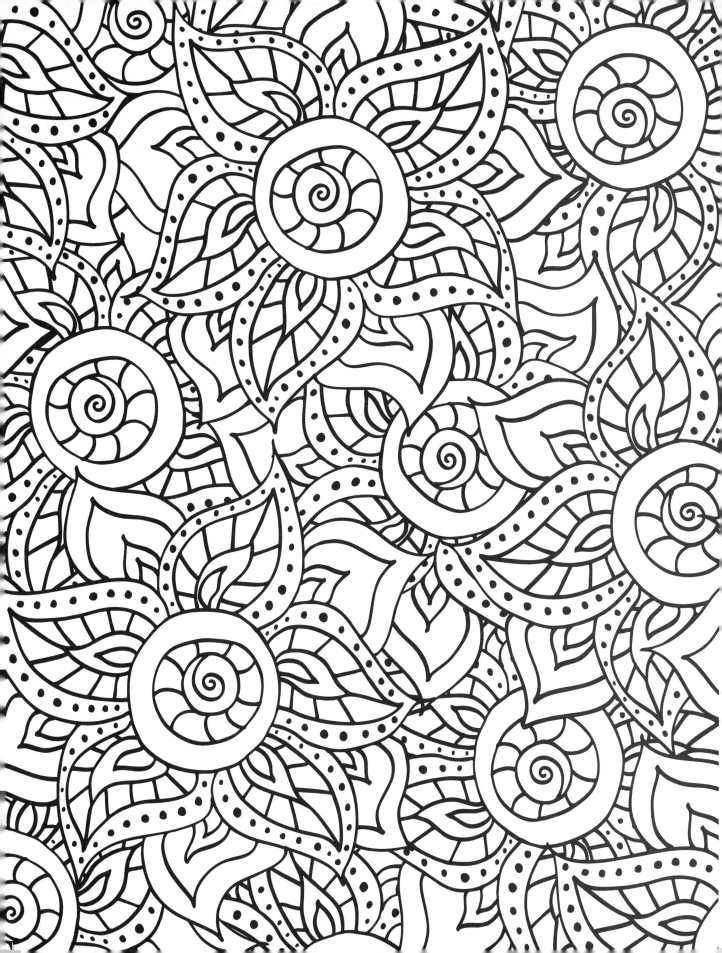

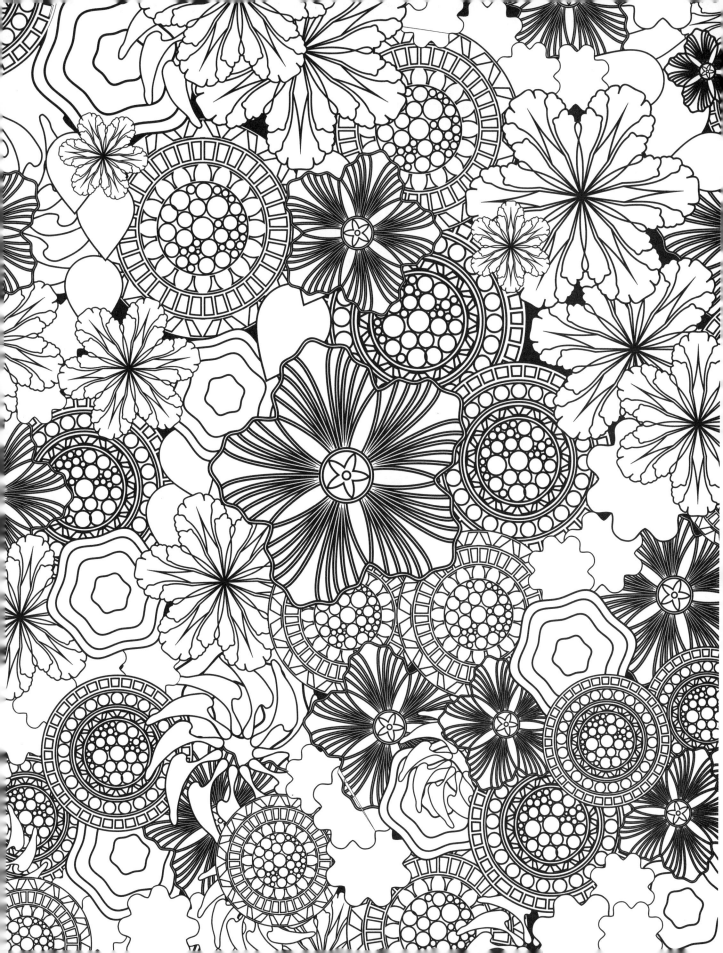

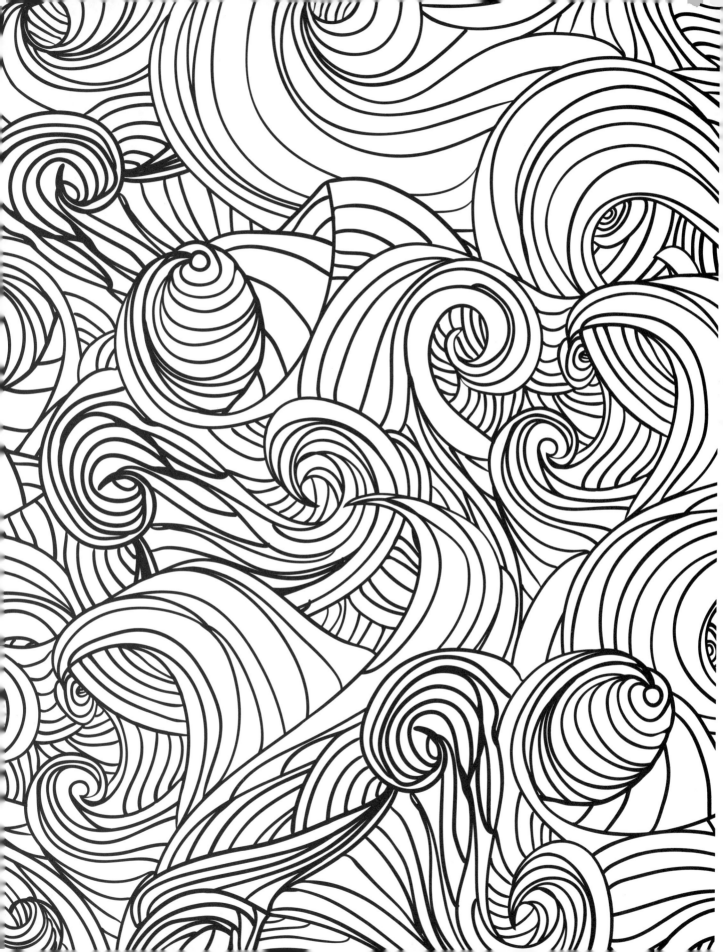

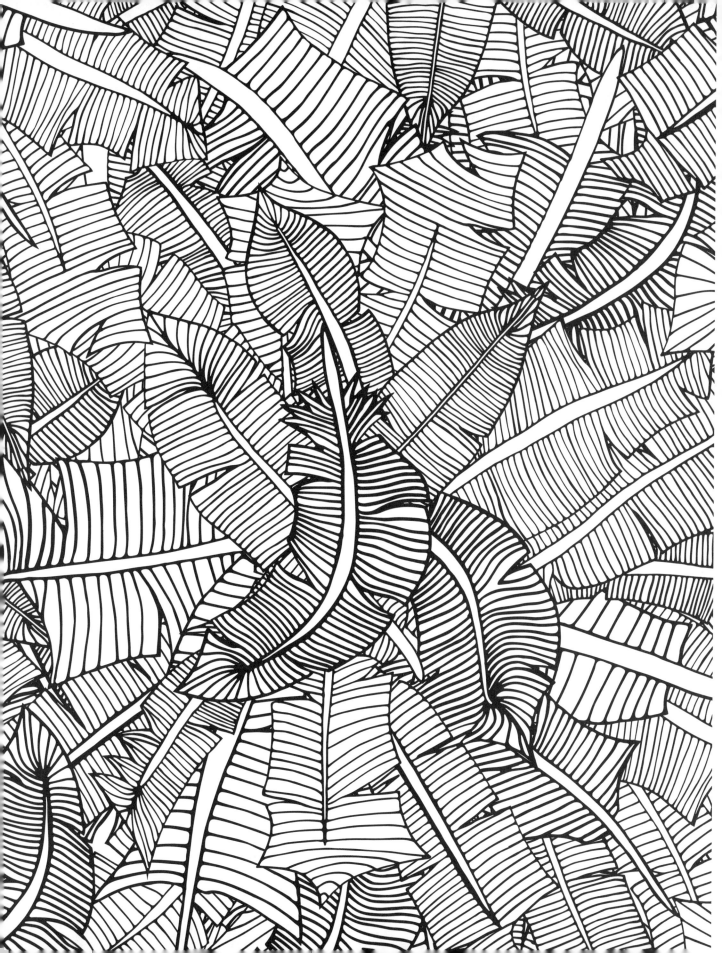

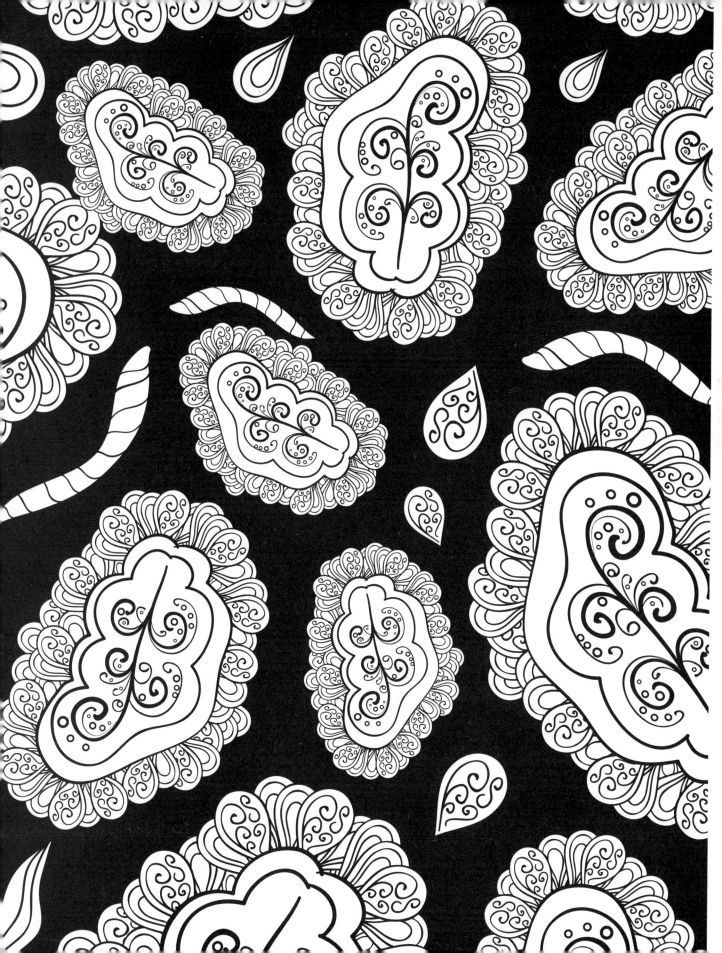

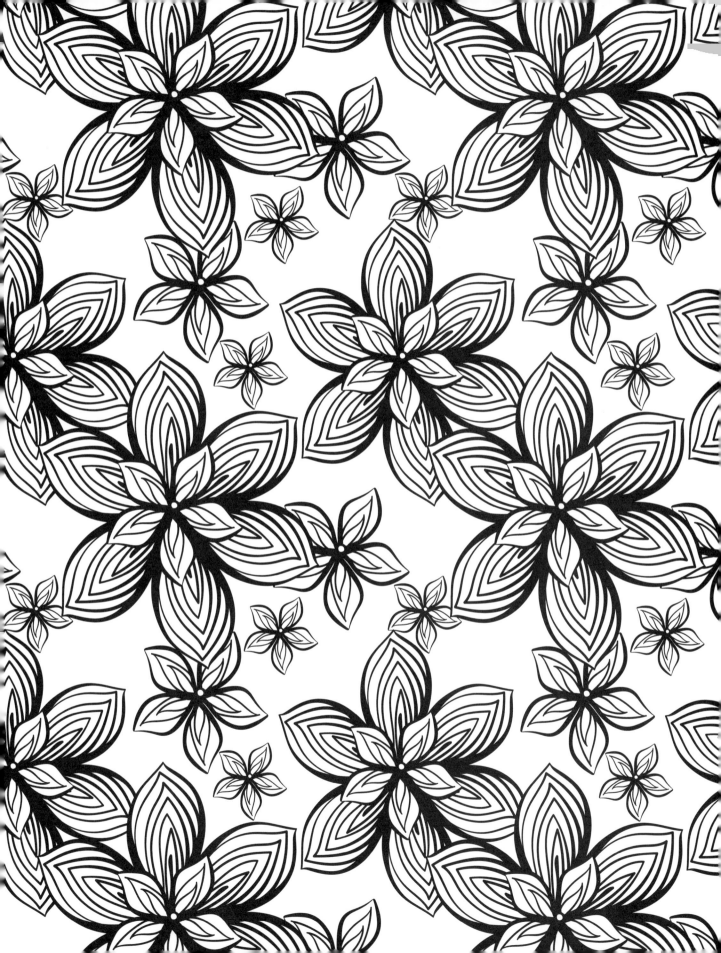

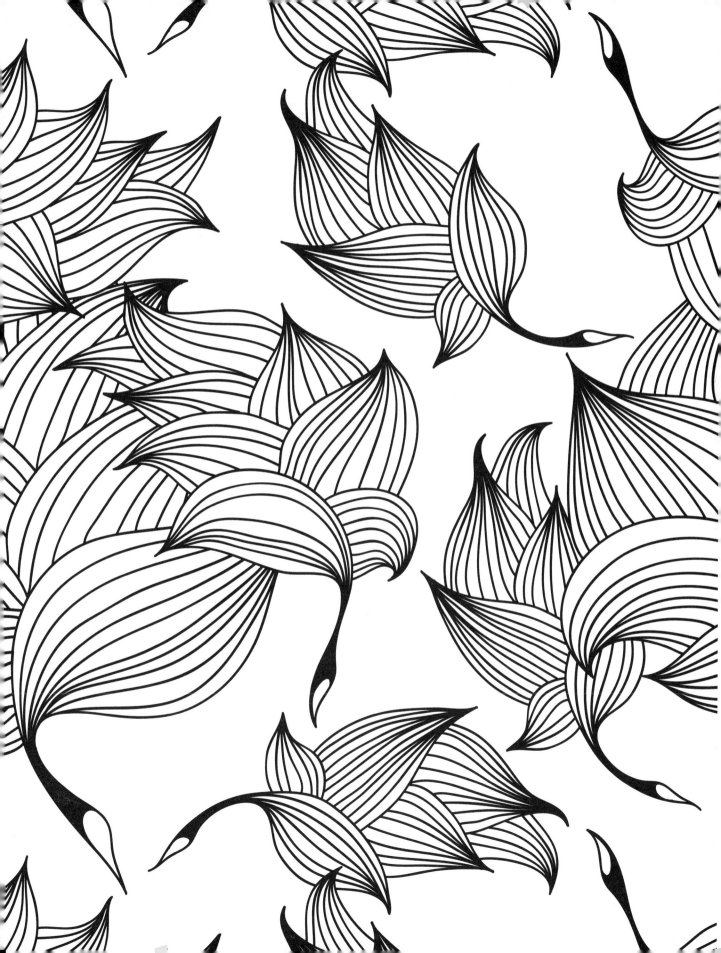

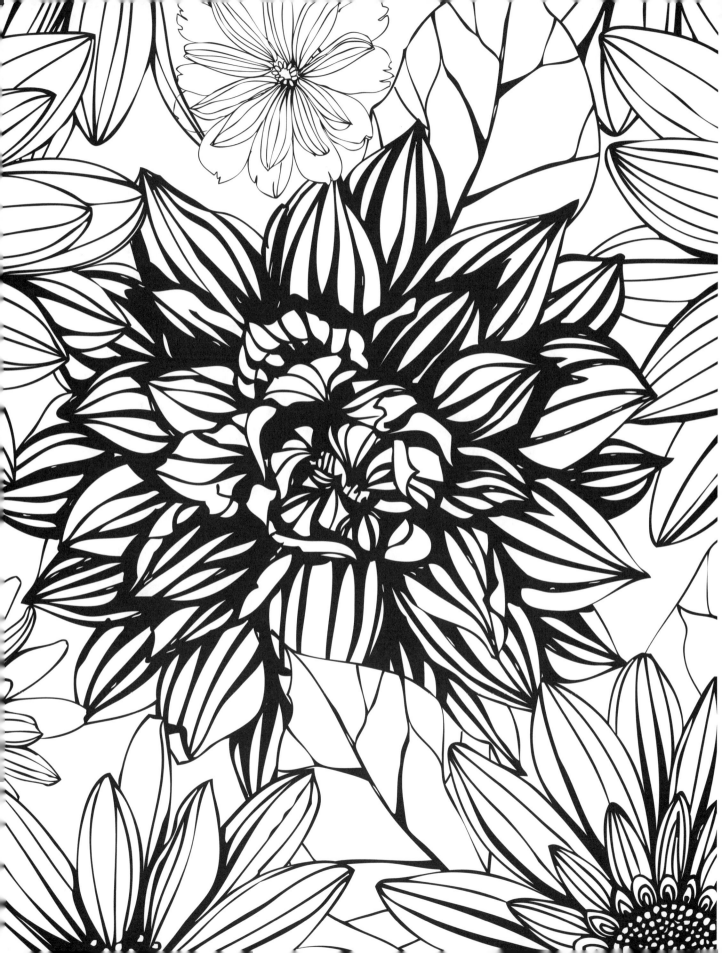

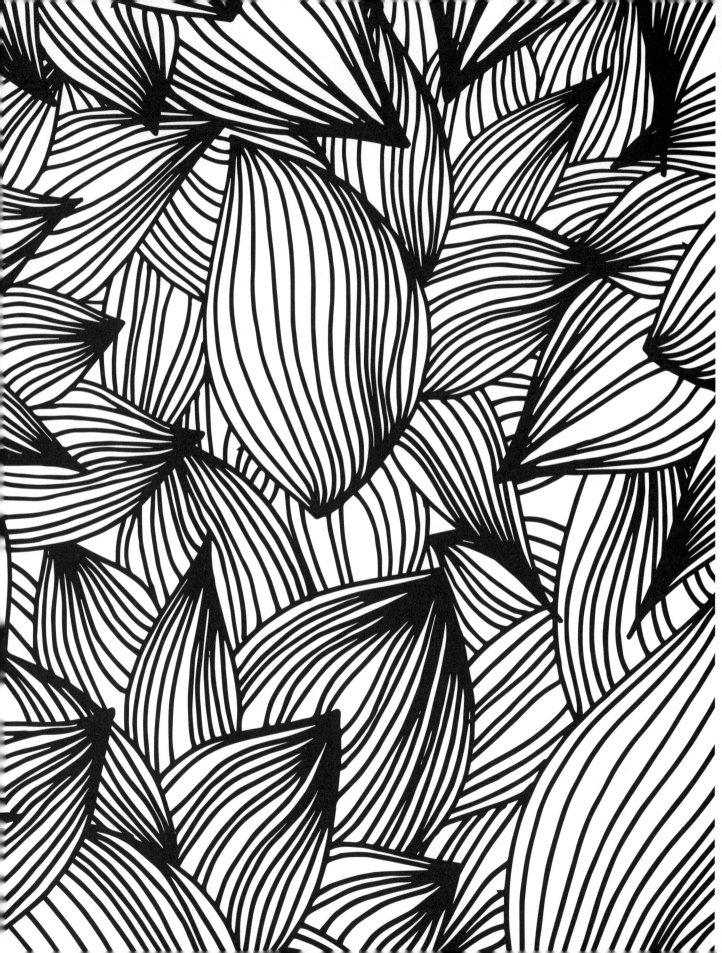

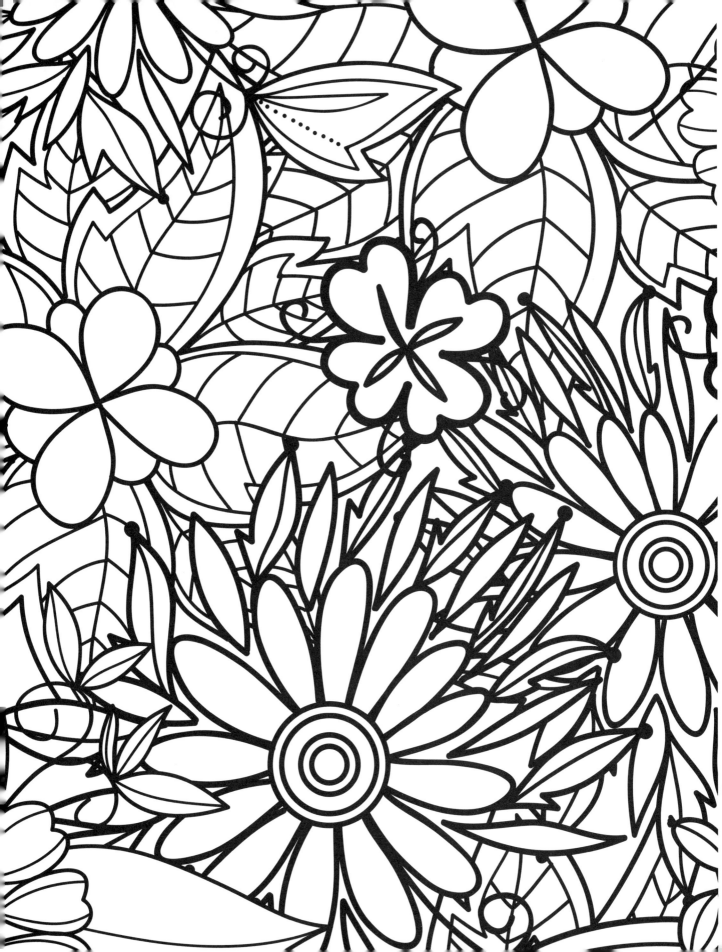

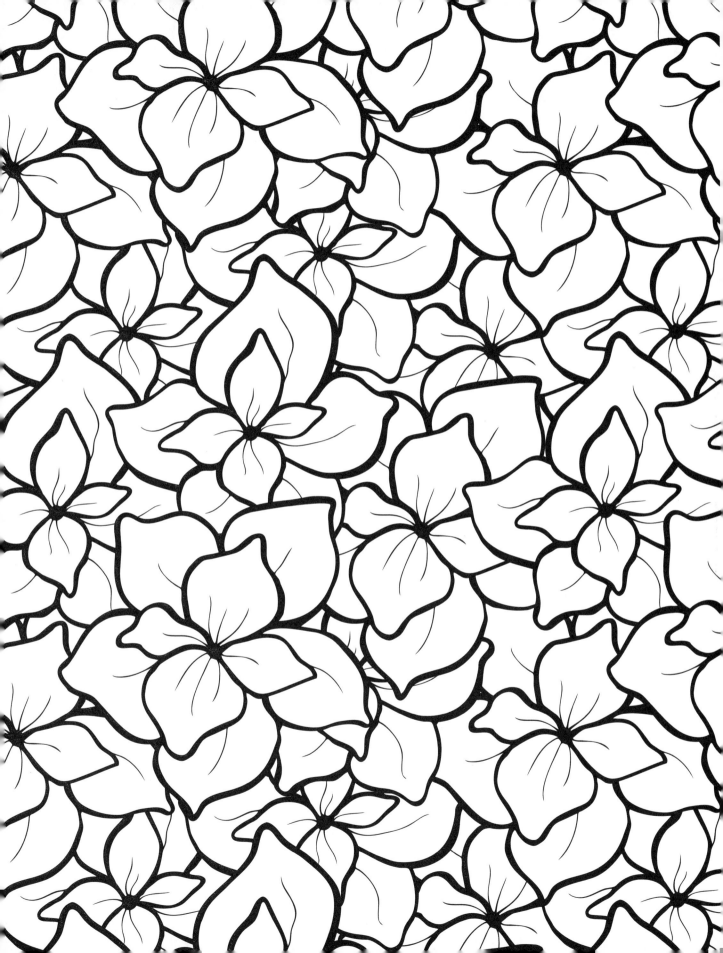

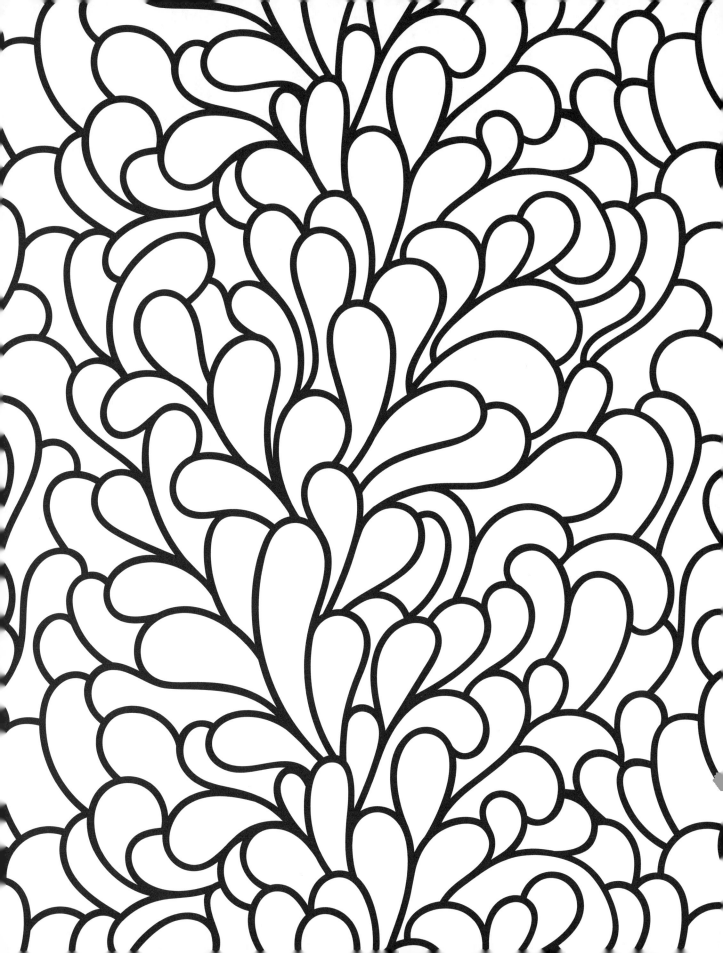

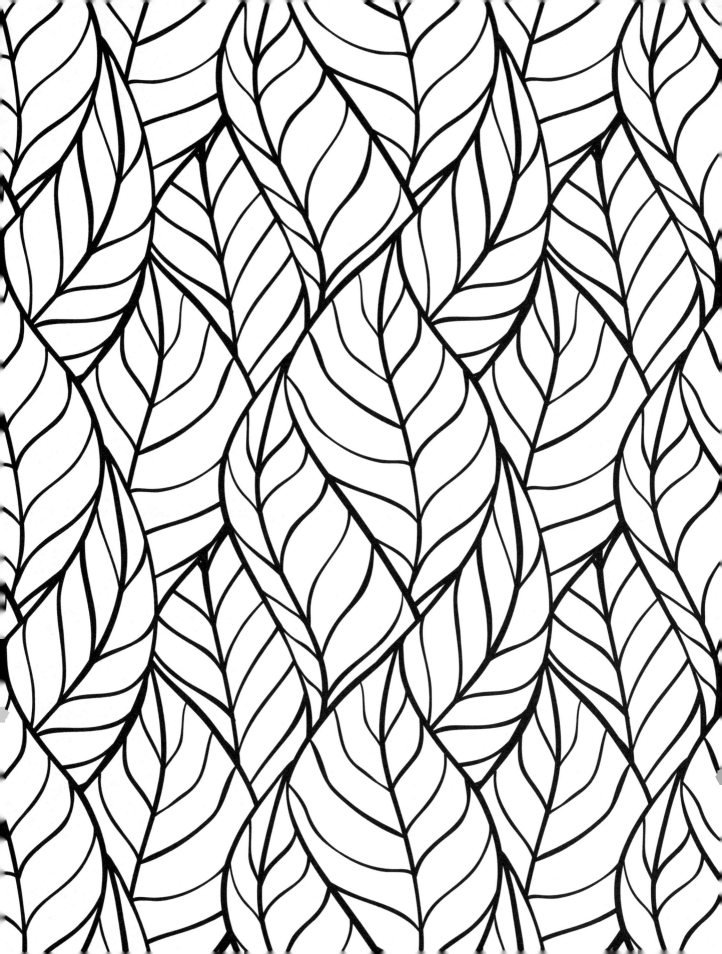

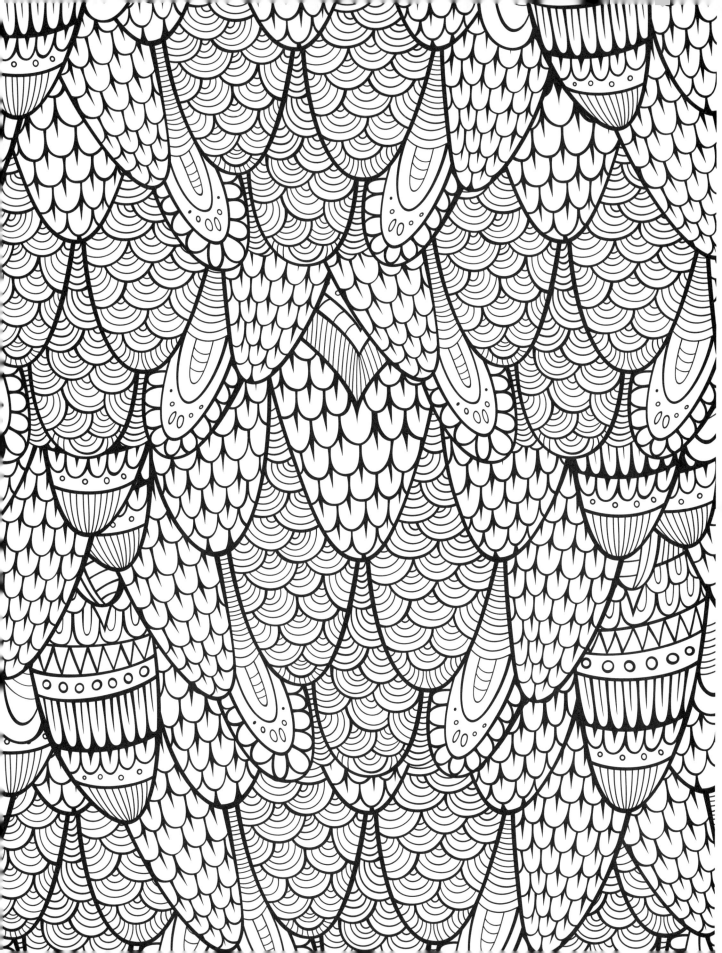

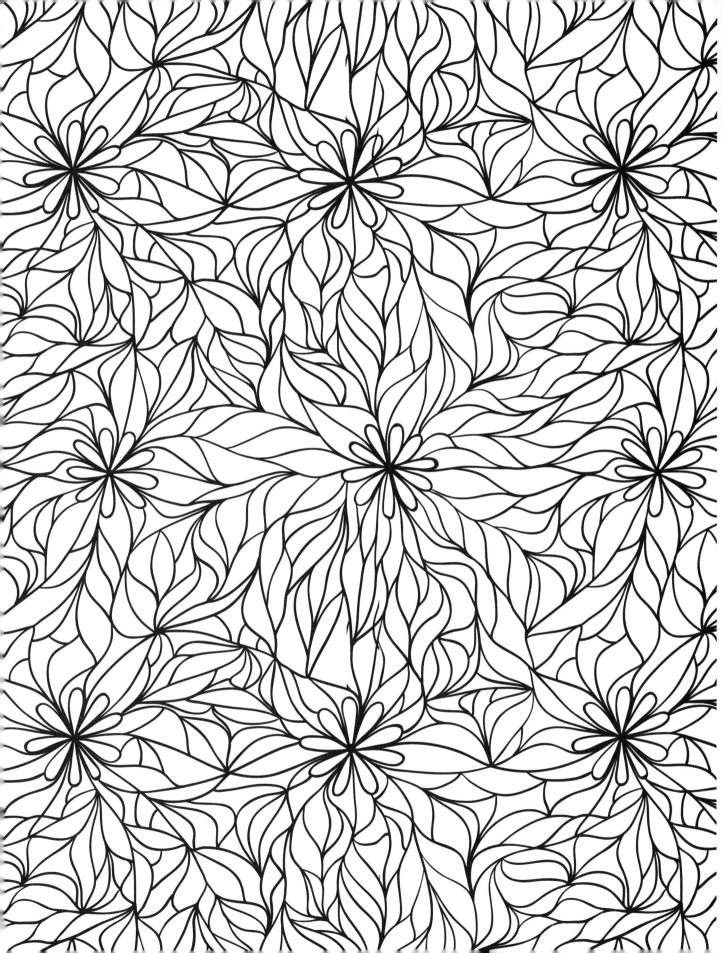

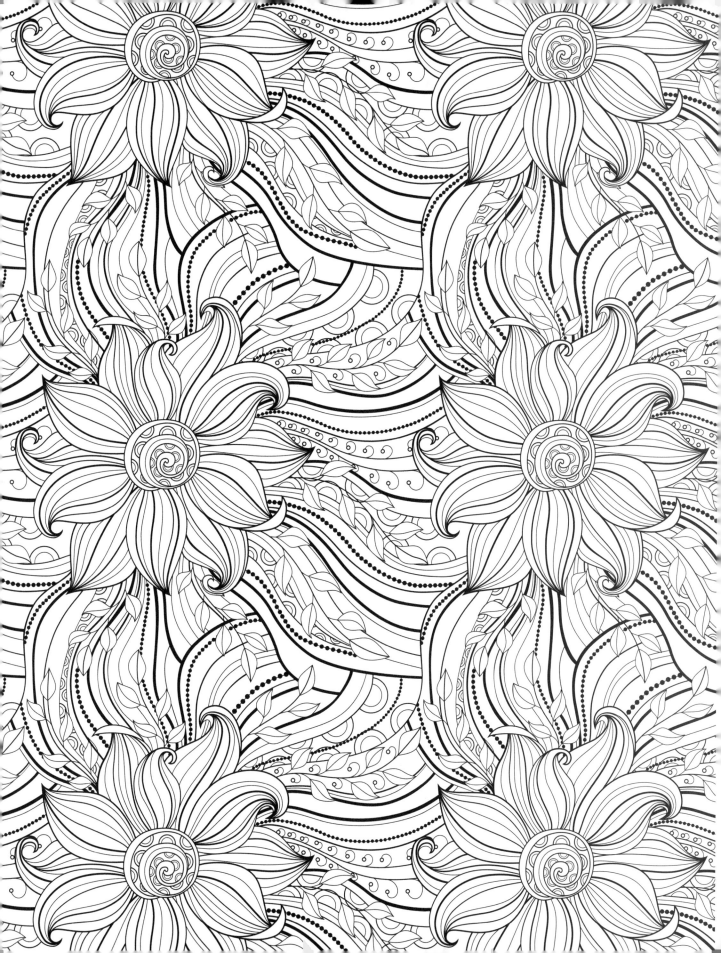

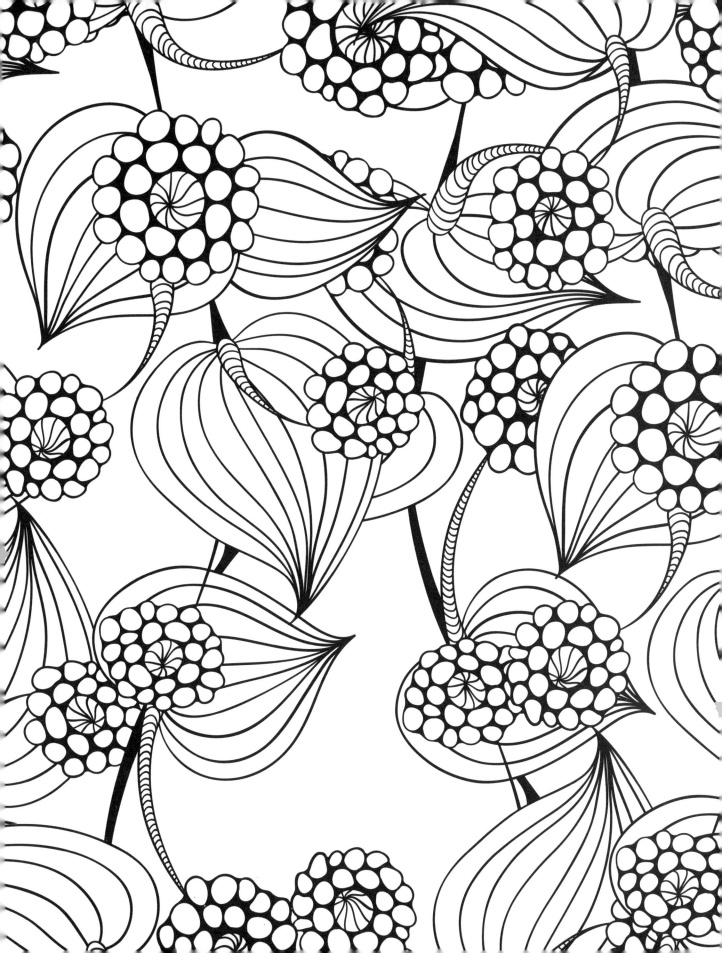

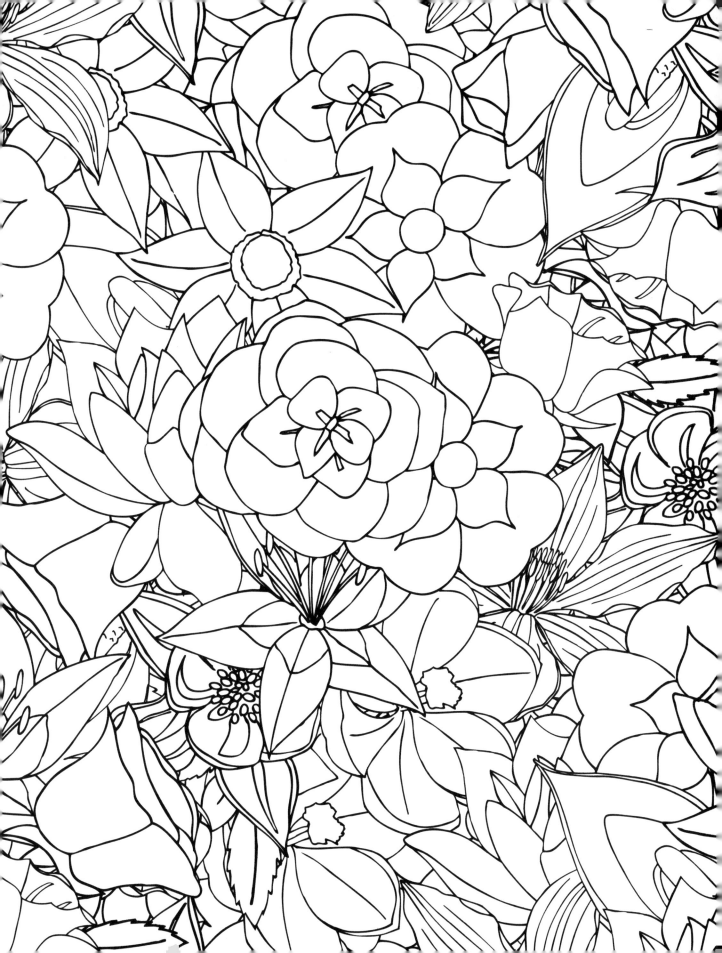

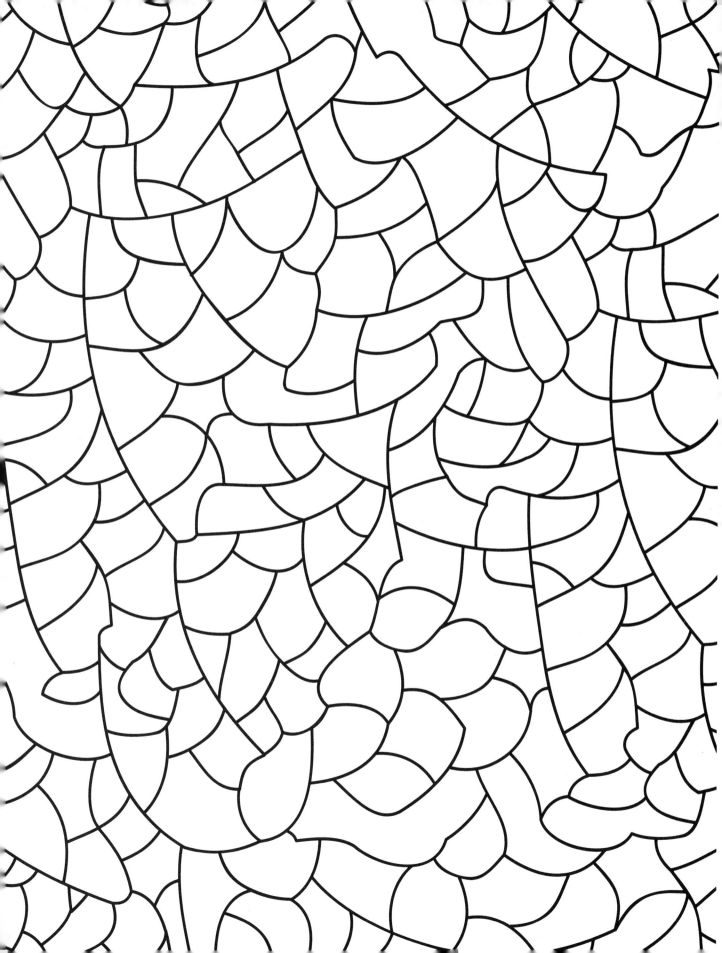

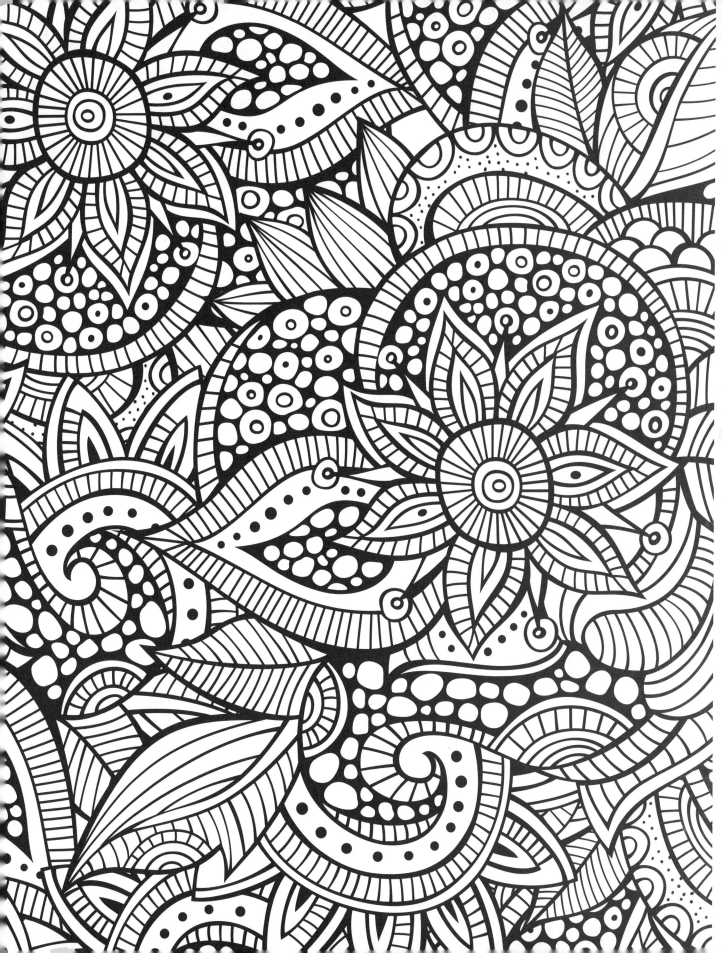

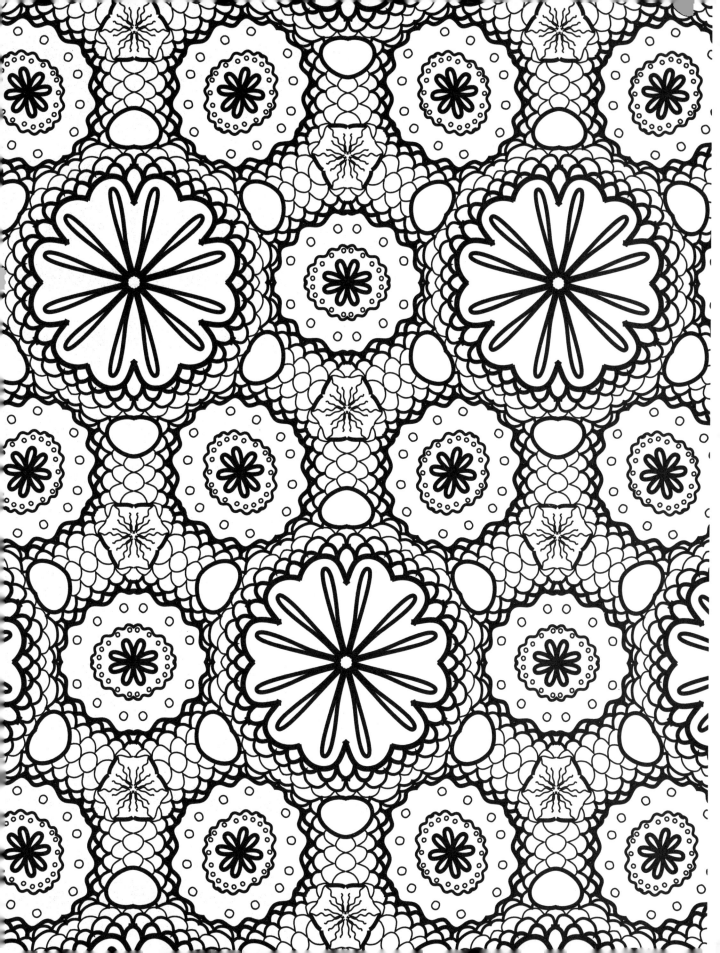

Publisher's Acknowledgments

Senior Acquisitions Editor: Tracy Boggier
Development Editor: Victoria M. Adang

Project Coordinator: Antony Sami
Cover Images: © Vorobyeva/Shutterstock.com;
© Anna Ievtushenko/Shutterstock.com